Studio Lighting

A PRIMER FOR PHOTOGRAPHERS

Acknowledgments

Thanks to all the kind photographers who lent me their beautiful pictures; to Natalina Nanni at Paul C. Buff, Inc. for lending me their excellent flash units; to William Jordan at The Denny Manufacturing Company Inc. for the loan of several lovely backdrops; to photographer Scott Van Dyke for the use of his studio; and to my models, who were delightful and very patient.

Front cover: Large photo by Brian King; balance of front-cover images by the author.
Back cover: Photo by Frank Frost.

Published by:
Amherst Media, Inc.
P.O. Box 586
Buffalo, N.Y. 14226
Fax: 716-874-4508
www.AmherstMedia.com

Publisher: Craig Alesse
Senior Editor/Production Manager: Michelle Perkins
Assistant Editor: Barbara A. Lynch-Johnt

ISBN: 1-58428-135-9
Library of Congress Control Number: 2003112491

Printed in Korea.
10 9 8 7 6 5 4 3 2 1

Contents

Photo by Jill Walz.

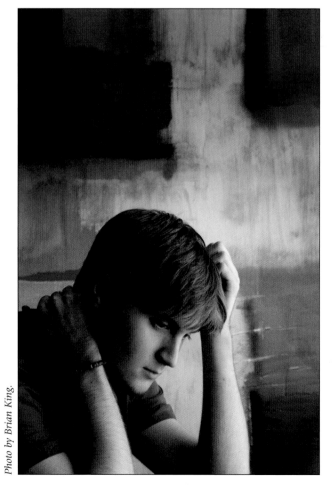

Photo by Frank Frost.

Photo by Brian King.

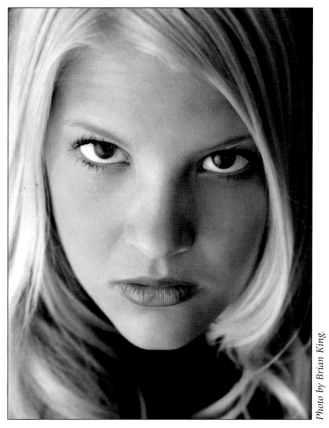

Photo by Brian King.

About the Author

After switching to photography from a career in industrial design, Lou Jacobs Jr. found his niche in the photographic field. For many years, Lou worked as a freelance editorial photographer; additionally, he has authored many articles for numerous magazines, also providing the photographic illustrations. He has written twenty-five books on a diversity of photo subjects, starting in 1960 with a book about variable contrast papers. Among his other titles are the best-selling *How to Take Great Pictures with Your SLR* (HP Books 1964 and 1974), as well as *Photographer's Lighting Handbook* (2001) and *Take Great Pictures: A Simple Guide* (2003), both by Amherst Media.

Lou has written and illustrated fifteen children's books and has taught photography courses at several universities. Some of Lou's fine art black & white photographs, including portraits of Edward Weston and Man Ray, are in museum collections. In 1984 Lou was national president of ASMP (American Society of Media Photographers). He lives in Cathedral City, CA with his artist wife Kathy.

Contributing Photographers

• Frank Frost of Albuquerque, NM, discovered his love for photography in junior high, and at age sixteen he photographed his first wedding. After high school he worked at McDonalds to save money for a studio, was a manager at nineteen, and at twenty-two he bought a mom-and-pop studio. He continued to manage a McDonalds and started studio appointments in mid-afternoon. After two years, he said goodbye to the restaurant. Today, in a far more elaborate studio, Frank has become a family portrait specialist who also photographs weddings and seniors. He employs a staff of seven in surroundings he designed to give clients a sense of "home." He does all the studio's photography, and his friendly attitude attracts children, brides, and teens. Outstanding customer service has also contributed to his success.

• Peter Gowland has been famous for decades for his skillfully lighted images of beautiful and sexy women seen in dozens of magazines and twenty-seven photography-related books that Peter and his wife, Alice, have written. (A recent Gowland book from the publisher of this book is *Classic Nude Photography* [2001].) The couple published their first girls-in-bikinis pictures around 1946 and began an on-going series featuring beauties at the beach in the 1950s. They have lectured about glamour photography in the United States, Canada, and Australia. Their home near the coast in Los Angeles includes a pool with underwater viewing windows and a beautiful studio where they mix daylight and flash. Along the way, Peter designed a 4x5 twin-lens camera for his own use, which led to a custom manufacturing business. Sixteen different versions of Gowland cameras have been produced.

• Lou Jones is a busy studio and location photographer and, like Robert Rathe, was a colleague of the author's on the ASMP board of directors for a

decade. He's run a studio for more than twenty years, and his third and current studio is located in the heart of a warehouse district in the middle of Boston, MA. It's approximately 12,000 sq. ft. "You can drive trucks through the back door," Lou says. Most of his commercial work is corporate/industrial advertising and other assignments such as portraits of executives, politicians, or celebrities. He specializes in photo-illustration, in the studio and on location, and has been published in many magazines including *Time, Fortune, Reader's Digest, People,* and *Geo.*

• Brian King started attending classes at Columbus (OH) College of Art and Design while he was in grade school, working in various media. He studied photography in high school, was exhibited, and enrolled at the Ohio Institute of Photography. Though King confesses that he did not have much interest in portraiture after graduation he took a job to photograph seniors (the high-school kind) at Cubberly Studios in Delaware, OH. The studio environment had a positive influence, and Brian became an enthusiastic expert at portraits. He has been a top shooter at Cubberly for ten years, and in that time has polished his techniques and allowed himself the freedom to experiment, as some of his photographs in this book show. "Develop good relationships with your portrait subjects," he advises, "and they'll be back."

• Roy Madearis Studio is known in Arlington, TX, and the vicinity, partly because of Roy's partner-and-wife's "Watch Me Grow" plan, which provides yearly children's portraits at reasonable rates. Roy wanted to be his own boss when he studied business at the University of Texas. But he was attracted to a museum darkroom class that led to his fascination with photography, and he shot weddings for friends. He also worked at a bank, practiced his business skills, and eventually opened a studio in downtown Arlington. He says he had little portrait or wedding experience then, but taking classes over a dozen years helped make him a specialist. Today he's expanded to his third studio in a historical old home and is successful enough to be open only Tuesday through Friday.

• Victoria Mal has been in the photo industry for thirty years. Her company, Marketing Plus, works on projects from her office in Sedona, AZ. She has done portrait studio marketing and sales, has produced lecture tours for photo clients, worked trade shows, and has also lectured widely on photo sales and marketing. She has the degree of Photographic Craftsman, and has worked for many associations and companies.

• Derald Martin, who died in 2003, was an old friend of the author and an enthusiastic photographer most of his life. During much of that time he was chief photographer at a division of Northrop Corp. For his own creative satisfaction he was also a studio and location photographer for five decades, specializing in what has become a remarkable series of narrative nudes. His first images in the series were made while he attended Art Center College of Design. At his home in Joshua Tree, CA, the dining room was a full-time studio, where at least three studio flash units stood at the ready. Derald also photographed in the nearby desert where he traveled to isolated locations on many dirt roads to help maintain privacy for himself and his models.

• Allison McBee was a staff photographer at the Palm Springs, CA, *Desert Sun* when she made the two group photographs in chapter 9. At the newspaper she primarily photographed people in location and studio situations. Currently she and her husband are photographers for the *Lumina News* and *Wrightsville Beach Magazine* in Wrightsville, NC. Their assignments are mostly environmental por-

traits and interiors, plus event and spot news (late-breaking or tight-deadline) coverage.

• Debrah H. Muska owns a photography studio, called Animal Images, in Newark Valley, NY. The essence of her photography is the harmonizing of two passions: respect and love for animals and an enthusiasm for photography. In 2003, she received her Photographic Craftsman and Master Photographer degrees from Portrait Photographers of America (PPA). Debrah has received many awards for her images, including two Kodak Gallery Awards and a Fuji Masterpiece Award. She is the author of *Professional Techniques for Pet and Animal Portrait Photography* (Amherst Media 2003).

• Robert Rathe of Fairfax, VA has a reputation for lighting, often using colorful lights to illustrate high-tech subjects for industry and advertising. He also does evocative portraiture for publications and corporate clients. He has a degree in fine arts from George Washington University. An early interest in journalistic photography led to a job shooting a presidential gala that included President Ford and Vice President Rockefeller. A few years later in his first studio, he did magazine covers and illustrative still life images. In the 1990s, Robert built a two-story studio behind his home where he does product shots and other assignments. Some of his flash units are packed for traveling, and on special projects he uses a Hosemaster with which you "paint" with colored light.

• Roger Rosenfeld has been in business since 1982, and during that era has produced high-quality photographs for ad agencies, designers, and business firms. His studio in San Rafael, CA (just north of San Francisco), specializes in images of products such as food and wine, which he enjoys shooting. Roger graduated from the University of Pittsburgh and studied at the New York Institute of Photography, the School of Visual Arts, and Fashion Institute of Technology in New York. He was head of the photography department at ArtWorks in San Francisco, has worked at several other studios, and is an associate photographer at South Park Digital.

Note: Photographs by Norm Kerr, Marge McGowan, and Jill Walz are courtesy of the Eastman Kodak Company. The author did not have contact with the photographers directly.

Introduction

To those who haven't tried it, studio lighting can be an unfamiliar world of electronic flash, tungsten "hot lights," reflectors, umbrellas, softboxes, seamless paper, and more. However, working in a studio offers photographers some clear advantages. Whether large, small, formal, or improvised, a studio setting provides a space and atmosphere that won't be interrupted, and that's a comfortable way to work.

A studio setting also offers increased control over lighting. Inside the shelter of your studio, you can better predict the effects of your lighting and can easily repeat effects that please you. This is a big advantage for portrait photographers, in particular, as good portraits rely heavily on how well one can control the light.

For these and other reasons, a studio setting helps me feel free to experiment with lighting, posing, and composition. In my studio, I'm inspired to shoot more sensitive, appealing images.

About This Book

This book will show readers how to best use a studio space—whether large or small, in a spare room or garage, or temporarily set up in a living room where you must rearrange the furniture before you can begin your session. Whether you shoot portraits or products, you will find in

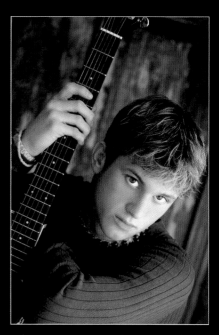

It's easy to see why teen clients appreciate the artistry of Brian King. Expert lighting and dynamic poses are among the reasons.

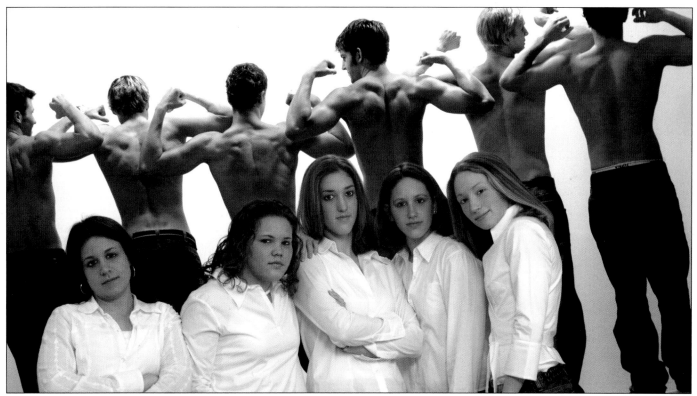

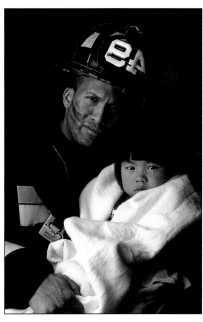

Above—The ladies in front brought the young men in the background for a session with Brian King, who lighted the group using several softboxes. Another image from this session can be seen on page 96. *Left*—Dramatic lighting is made realistic in a studio setting. Longtime professional photographer Lou Jones made this picture for a pharmaceutical company's advertising. "These are models," he told me, adding, "In total darkness I opened the camera shutter and fired a bank light (large softbox); the main light was at the left. Then I covered the lens with a dense diffusion filter and popped another strobe (electronic flash) on the background to create a soft, faint texture." These techniques will be explained in later chapters.

this book words and pictures that explain lighting techniques, equipment, and other concepts essential to creating high-quality photographs of any subject.

Perhaps you already enjoy a studio setting where electronic flash or hot lights capture magical expressions or lively action. If so, look forward to discovering decorative studio backgrounds, props like musical instruments or toys, and accessories that will make your photographs look more interesting and help your subjects to feel more comfortable.

If you don't have much indoor lighting experience, however, shooting portraits or still lifes outdoors in soft shade or reflected sun will be good training.

Studio photography has helped me illustrate some previous books and do magazine assignments. While the lighting process comes easier now than it did when I was a rookie, lighting is always a challenge.

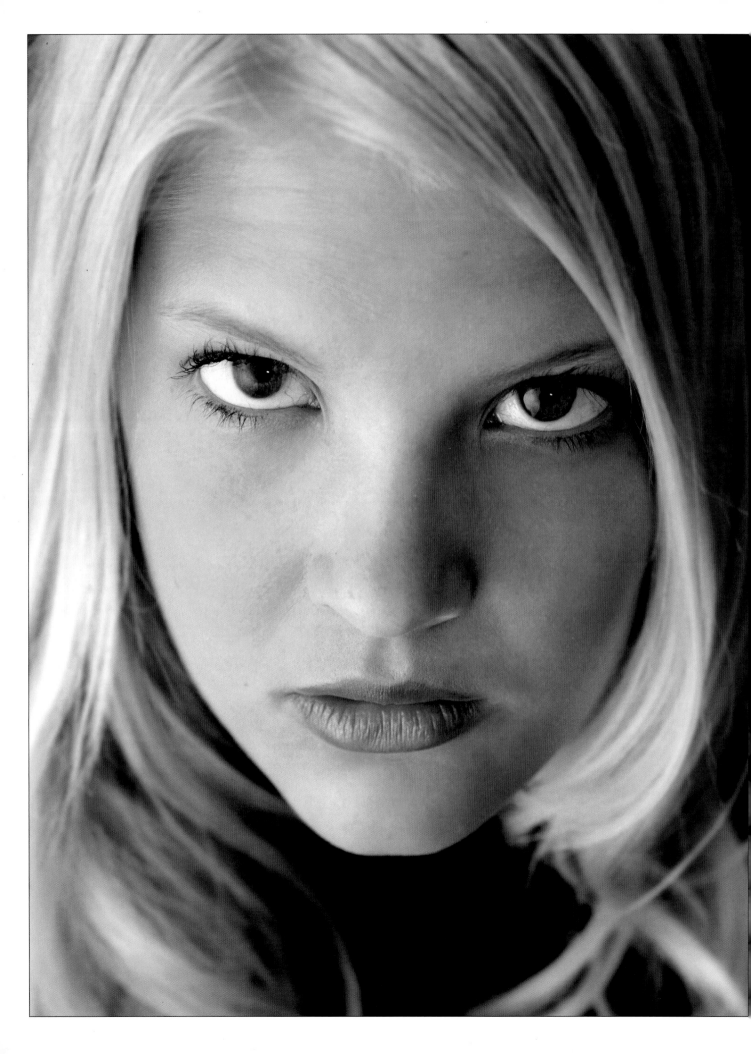

Facing Page—*The eyes are domi-nant in this lovely portrait by Brian King. He placed a softbox at the left, reflected in the model's eyes, and used a white reflector on a stand at the right. Brian shoots digital images.*

The leading edge is always where to put the lights, and how bright they should be. You may struggle with how shadows should look, and you usually have to decide when light needs softening. Lighting simplicity is always a good rule of thumb. You will find it's both challenging and rewarding to manipulate light and shadows on a face or still lifes. The path to success is paved with your experiments, and you'll find the inspiration you need to try new techniques in this book.

When you light right, at least in the beginning, it could be helpful to make notes on the backs of prints about where the lights were and whether you used a softbox, umbrella, or reflector. (You'll learn more about light modifiers in chapters 3 and 4.) Later, when you maneuver the lights, the prints will serve as a reference. Remember: it takes time to train your powers of observation so you know when lighting really works. Outdoors you use natural lighting effects, but indoors you can take the credit—or the blame.

While at first the responsibilities of lighting your subjects may seem intimidating, your photography will be meaningful—I promise! If you become upset that your subjects are not as slickly lit as pictures seen in magazines or books, remember the Cat in the Hat, who said, "Never

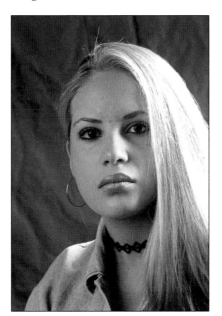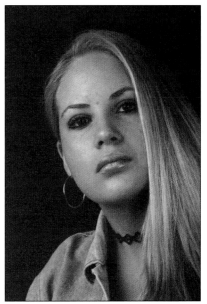

Left—*The same model is lit two different ways for comparison. Here, one flash was pointed into an umbrella, placed higher than her head at the right. At left was a dimmed-down umbrella, which brightened the shadow side of her face. There was no light on the background.* *Right*—*While this was the same pose, the lighting created a slightly different mood. I used one flash only, a softbox (a flash inside a diffusing box) at left of the camera. It was dimmed to be more subtle—proof that studio lighting is rife with possibilities.*

fear." As you overcome shortcomings, you will be making subtle lighting decisions that please you and other people.

Lighting is an exciting activity that can give you cool pictures and new self-confidence.

Now What?

Before we move on to the next chapter, take a few moments to study the following points. They will help you to prepare to learn and to absorb a lot of information in a relaxed and confident manner.

- Find a quiet spot to take pictures with lights indoors. Clear space in a room or garage. Details are found in chapter 1.
- Think about how your cameras and lenses will adapt to shooting portraits and still life images.
- Is your lighting equipment adequate? If it's portable flash, can you mount it off-camera and fire it remotely? If it's hot lights, will your subjects sometimes sit still for $1/4$ second? Do you have umbrella reflectors or softboxes? See chapters 3 and 4.

Peter Gowland, noted for his pretty girl pictures, turned his talent to a kitten in a basket. He explained, "The basket was placed in front of a six-foot-square piece of red felt, stapled to a wood frame. I used a single thirty-six-inch Larson Soff-Box, and the kitty watched, fascinated." The portrait was taken with a medium-format Hasselblad camera and a 150mm lens.

> Lighting is an exciting activity that can give you cool pictures and new self-confidence.

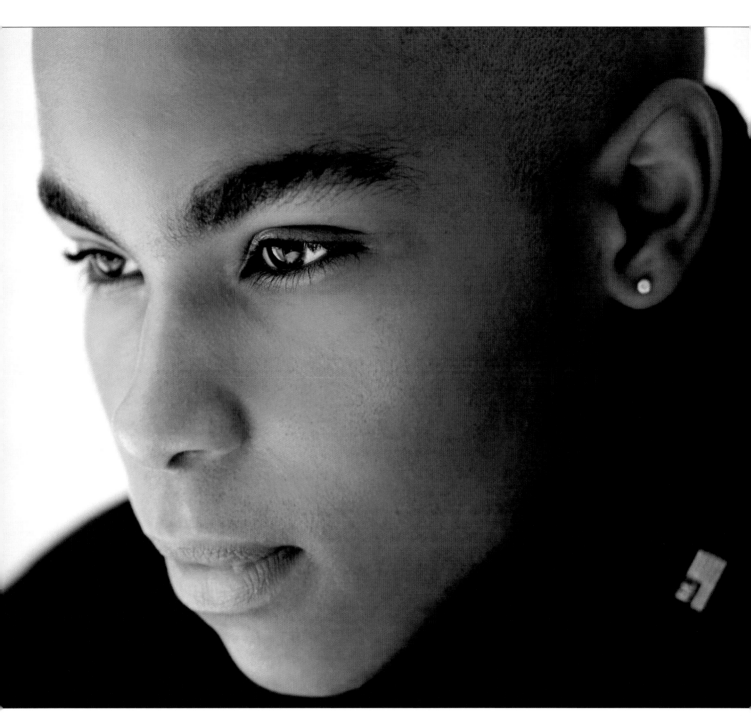

I would call this a lovely mood portrait by Brian King. Window light from the left was reflected softly at the darker side of his face. The background flash came from an umbrella.

• Just for yourself, write a few paragraphs about what kind of pictures you want to shoot in a studio, and outline the ways in which you'd like to improve your lighting skills. Writing helps clarify your motives and involvement. What will you do with the portrait and still life pictures you shoot? Hang them? Sell them? Give them away? Do you hope to achieve professional skills and status?

The Makings of a Studio

Most of us start photography with outdoor scenes and details (like sculptural rocks in the subject's background), plus natural light portraits. In dim light, we use flash in or on the camera. On a bright day, it's relatively painless to take pictures of subjects from children to horsemen galloping along dusty trails. It is common to find or wait for the "right light," because we're more inspired to shoot when the light is beautiful, soft, moody, or angled just so. Then we can concentrate on expressions, action, composition, and making subjects look appealing. Outdoor light variations become familiar, and we can often shoot before the light changes.

While it takes skill to shoot good pictures indoors or out, differing qualities of daylight and artificial light create special challenges.

Studio Advantages

A studio is valued by those who also enjoy photographing people and things with flash or floodlighting in a setting where light can be controlled and pictorial conditions can be created day and night, rain or shine. At first, some of us learn to shoot in a restricted space, where lights and subjects may be awkwardly placed. But wherever you start, there's a sense of creativity inherent in aiming and modifying lights

The lighting is even, and soft shadows indicate that the subject was lit from above and to the left. How was this lighted? I used shady daylight, though the light might easily have come from a softbox. The dish of candies was placed in shade, and I held a white reflector to brighten it and create more contrast. My SLR with a 50mm close-up lens was loaded with Kodak Ektachrome slide film. In fact, the picture was made in an outdoor studio setting.

In this beautiful high key portrait, Brian King made this teen model look like a princess. The subject was positioned facing a large window, and the incoming light bounced around the alcove to provide fill. A reflector placed off to the right made it all smooth.

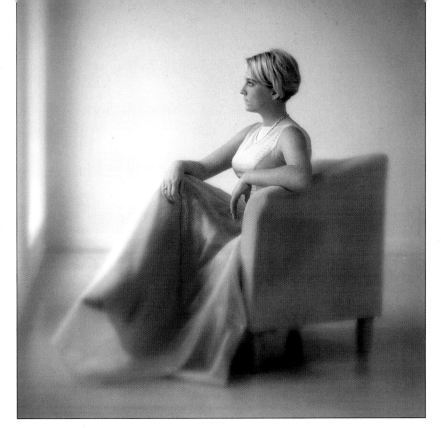

Wherever your studio, consider it a photographic gym where you work out.

with reflectors, softboxes, etc., as you practice the art of studio lighting. With experience, you come to know how large and close and bright flash or floods should be, and how subtle lighting variations make people and things become photogenic. It might be said that mastering studio lighting separates the men from the boys—or the women from the girls. Studio photography is not so difficult; it just requires its own techniques.

A studio, improvised or more formal, is a terrific photographic training area. Outdoors you are less confined, but working indoors gives you the means to resolve a special variety of lighting issues. Wherever your studio, consider it a photographic gym where you work out. At first you may sweat a lot, but then exercises become easier, until you're more fit as a photographer. A treadmill-type gym helps you improve your body. A photographic studio helps train your perceptions of light for faces, flowers, action, products, etc. Training results in lighting techniques becoming easier and more effective, using film or digital cameras, which I know from my personal—and sometimes demanding—experience.

In a studio setting, because light sources are smaller than the sun (you noticed?) and you can manipulate them, you may tend to take pictures more *carefully* than you do outdoors. (Note: *Carefully* can be supplanted by shooting rapidly when you have the lights right, a model looks great, and your enthusiasm is driving you. Have plenty of film on hand. In a careful hour I can expose seventy-two 35mm frames

Top—Lou Jones made this wide-angle photograph of his studio in Boston, MA. He told me, "The studio is large enough to shoot cars, one of which is in the background, and there's still room for an assistant to set up a still life in the foreground. A softbox was directed at the woman from top right and more strobes brightened the background set." Besides studio work, Lou does a lot of location shooting across the U.S. for corporate and advertising clients.
Bottom—This is part of my borrowed shooting space in a corner of a friend's studio. At top left is part of a softbox, behind it is an umbrella, and at right is a quartz light, with an AlienBees flash at rest on the floor. Behind the model is the wheeled background rack I built, which is illustrated in chapter 5. Out of sight at left is a table for accessories.

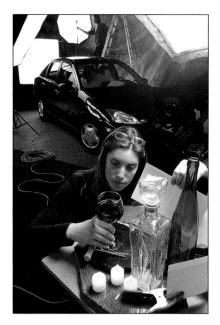

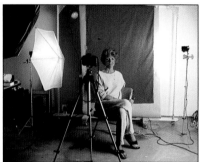

gleefully.) Indoors you have to design your own lighting effects, along with posing people or setting up still life compositions. You will discover typical and tricky ways of using lights. There's always the quest for where you want highlights and shadows; the responsibility can irk you, but lots of useful pictures are your rewards.

A Studio at Home

Most photo schools and courses teach the art of lighting. Instruction begins in a studio where the principles of maneuvering lights are demonstrated and practiced. Various light sources are available, so students are stimulated to think thoroughly about how lighting makes or breaks a picture. With the same viewpoints you can launch your own studio basic training and discover unexpected pleasures, for fun and perhaps profit.

As a full-time magazine photographer, I often worked on location in homes, offices, and production plants (as well as outdoors). I learned to light interior areas where my subjects worked or lived, usually using floodlights. At home, I improvised a living room studio for portraits and still lifes. Furniture was moved out of the way, and I set floodlights on stands, direct or with umbrella reflectors. My models were assignment subjects or friends who sat on a chair or high stool, and background paper was hung from a horizontal bar supported by two special vertical poles (called Polecats) wedged between the floor and ceiling. (See chapter 6 for more details.) I once shot a long series of portrait lighting exercises of a model for a textbook I wrote (*Photography Today*, Goodyear Publishing 1976), and there's no way to tell that my pictures were taken in a temporary studio space.

Adapting Small Spaces. When a living room is too small to hang a background, move a chair to a light-colored corner, and use this as a portrait background. You can light a person's face and behind her

head, and an adjoining corner wall becomes a reflector. In fortunate circumstances that same arrangement can be just large enough to photograph two people at a time. Afterward there's not much to take down, and the lights can be stored in a closet.

Wherever there's enough space for your lights, background, and subject, you can set up a photo studio—whether it's in a room, garage, or other area. It's nice if the lights and other equipment in your home-based shooting space can remain set up between shooting sessions, but if not, try to store your equipment nearby. I've known hobby photographers who rented modest-sized empty stores not far from home where they outfitted adequate, but not fancy, studios. They cleaned the spaces and added electrical outlets, and occasional windows were draped for privacy. To the lights they had, some photographers added modifiers such as umbrellas or softboxes (more on this in chapters 3 and 4). Bathroom facilities may be required in a storefront studio.

Daylight Indoors. If you have limited photo lights, shoot near windows or large glass doors. Portraits made indoors by daylight can be lovely, especially when you use a reflector of some kind, such as white foamcore. In one home in which I lived, daylight came through two large sliding glass doors in the living room, and I adjusted the light with vertical blinds. When necessary I boosted the light by bouncing portable flash off the ceiling or a wall or used a warm floodlight fill. In daytime, when shooting color negative or slide film with just floodlights, the blinds blacked out the living room. (Filters can be used to achieve the same results. This topic is covered in chapter 2.)

In a home studio, with a 35mm SLR camera on a tripod, I usually work with two lights for portraits, plus one light on the background. A fourth light is available for edge lighting a subject's face and hair.

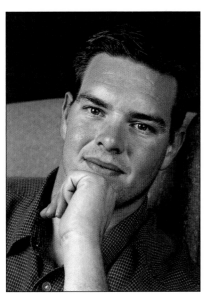

Top—This portrait was taken in a studio improvised in my living room after the furniture was moved out of the way. I used 600W quartz lights aimed into white umbrellas mounted on light stands. The background was a roll of heavy paper hung from a horizontal pole, and a bare 150W reflector flood was aimed at the blue paper. I used 200-speed color negative film in an SLR Canon A2 camera with a Canon 28–80mm, a favorite portrait lens. Bottom—This is a preview of a photo series of this model alone and with his wife in chapter 8. The main softbox shows as the larger reflection in Jamie's eyes, at left, and a smaller softbox was aimed from about 45 degrees at camera right. There was no background light. The lighting is simple and easy so it's popular for portraits. A hair light to visually separate his head from the background would have been useful too.

(These techniques are explained and illustrated in chapter 8.) Basic lighting techniques are similar at home or in a more formal studio.

Professional Photographic Studios

Whether you're ready to go into business or not, you should know a few things about professional studios.

Professional studios are found in many locations, such as former storage areas or lofts. Some pros remodel older buildings or homes to accommodate portrait studios, offices, etc. First studios are often modest. As success is earned, photographers move to larger, better-situated quarters. There are no rules for studio size and shape, but here are some guidelines that pros follow to make shooting more efficient and visiting clients comfortable. Form follows function.

- The size of the shooting space depends on need, availability, and cost. A portrait space can be 20 x 25 feet, while a commercial photographer's layout is often larger. As you become serious about studio work, arrange to visit a few professional spaces and make comparisons.
- In addition to the shooting area, a fully equipped professional studio has a reception area, office space, dressing rooms for models, a camera room where portraits are taken, a space to store and care for equipment, and an area for framing. Some photographers want a room or two for processing film and prints, and a computer setup for digital work. Remember that bathroom and storage areas are also necessary.

My Temporary Studio. To illustrate this book, I borrowed a shooting space that's about 30 x 40 feet in size in an area three times as large and two stories high. It includes two office spaces (one for owner Scott Van Dyke, and the other for staff) plus some of the facilities listed above. The owner's lights and other equipment are stored in or near a row of cabinets at one side of the studio. Scott often shoots on location, and it was easy to synchronize our photo schedules. When he later needed the space, I converted my large living room for portraits and still life pictures to complete this book.

Studio Costs

A Portrait Studio. Impressive portrait studios can be luxuriously furnished and expensive to build, but the cost of setting one up depends on how much investment a photographer wants to make. There is

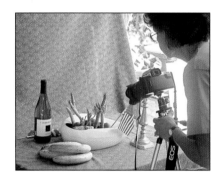

*Above—At the edge of our covered patio my wife, Kathy, arranged a still life using daylight and incongruous objects for the fun of it. A rolling storage box served as a table; it was covered with a fabric background that was taped to the wall. For some shots she held a white reflector at the left and exposed with the self-timer. The camera was a Canon Rebel 2000 with a 28–135mm lens, which focuses as close as fourteen inches. **Facing Page**—In this image, Brian King created an unusual and effective composition, in which the subject's face is dominant. His hair contains the design and the shirt borders the bottom. Window light with a reflector at right helps give the image unity.*

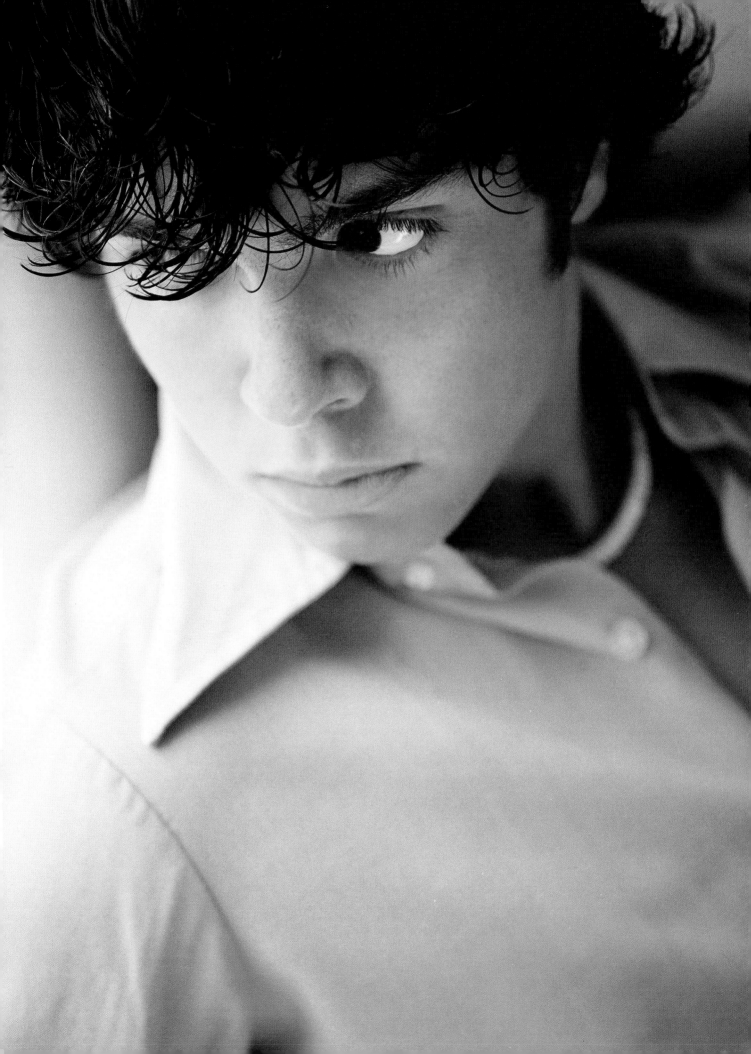

always a shooting area with space for groups of five or six. Some studios include separate space for photographing children. Fixing up a neat place in a pleasant location doesn't have to be very costly, but converting a space could be expensive depending on your needs.

An Advertising Photography Studio. Variations are based on size and how deep the owner's pockets are. A friend in Los Angeles had a new studio built and outfitted in an existing building. Construction plus additional photo equipment cost about $250,000. My friend does advertising photography (at $3,000 a day and up) and needed a space large enough to photograph cars.

When you get ready to set up studio in which to make a living, plan carefully. You may need new cameras, lenses, lights, accessories, backgrounds, props, computers, and other equipment. Check a complete list of typical startup studio costs in Edward R. Lilley's revised book, *The Business of Studio Photography* (Allworth Press 2002). He answers all kinds of questions for emerging professionals. See the reference reading list on page 121.

Outdoor Studio Arrangements

This book is concerned mainly with indoor studio lighting techniques, but on your way indoors remember that a "studio" can be improvised outdoors. Before Edison invented the lightbulb, the only sources of illumination studio photographers had were large, adjustable skylights and folding doors that could be shifted to modify light coming through a wall of large windows. In those days, film speeds were equivalent to an ISO of just one or two, long exposures were common, and subjects were steadied in iron head rests. Be thankful that, today, daylight photography on a porch or patio offers many more technical advantages.

Portraits and Products in Shade. Shade light can be a pleasure. Its pale shadows are often flattering to people, and when a still life composition needs more contrast, you can add flash, floodlights, or reflectors. Pose outdoor models on a porch or in shade opposite a natural reflector such as a light-colored wall. Or install a reflector such as a piece of sturdy white foamcore or a photo umbrella to brighten faces. Also consider using floodlights or flash outdoors as main lights with shade light for fill. Floodlighting will make warm pictures, while flash will match daylight.

In a shady area, attach background paper or fabric to a wall. Have your portrait subject(s) sit comfortably. Add lights, reflectors, or diffusers as described in later chapters. Arrange the equipment and sub-

Fixing up a neat place in a pleasant location doesn't have to be very costly.

ject(s) for good photography. Practice outdoors with studio flash equipment to better see what the modeling lights do at dusk or after dark. Some indoor studio flash techniques mentioned in chapters 7 and 8 can be practiced outdoors.

Lighting still life images in shade or partial sun is also very practical. Simply place a table against a wall and fasten background paper or fabric to run down the wall and across the tabletop, and you'll have an instant backdrop. Soft light may be indicated, but some still life compositions and products need partial sun for contrast that shows form or texture. See chapter 7 for still life lighting variations and pictures of a clamp and spotlight I used in shade with added flash.

A studio is a real asset for photographing people and things. Improvise one indoors or out until you're ready for a more permanent space.

Roy Madearis, a wedding specialist, is famous for touches like this quick image of a bride's bouquet in outdoor shade. Roy asked the bride to pause, knowing this would look good in a wedding album. Roy uses a Kodak 760 digital camera.

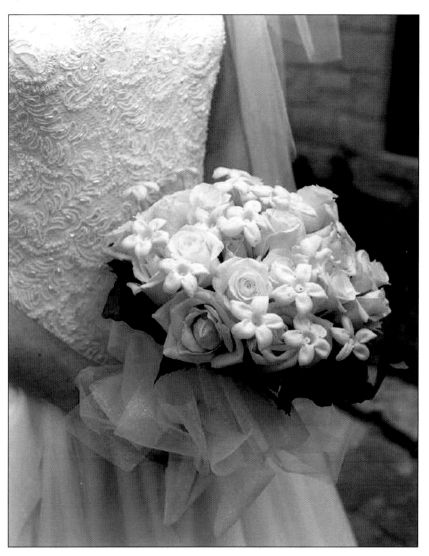

From motion picture studios and locations comes some of the most dramatic, artistic, and storytelling lighting you will ever encounter. Lighting for television can also be moody and craftsman-like, but it's created for a smaller screen. To view the best work by cinematographers in past years, look up "Academy Awards" on the Internet, and check the "cinematography" category for the names of award-winning directors of photography and their movies. As an example, Conrad Hall won an Oscar for *Road to Perdition* in 2003. Hall was a master everyone admired (he died in 2003), and his award-winning work stretches back to *Butch Cassidy and the Sundance Kid.*

Some motion pictures are lit for drama, mood, or mystery, and some for fantasy. For the film *Chicago* the award-wining lighting team was Jules Fisher and Peggy Eisenhauer. They designed the lighting of the musical on stage, and Eisenhauer was quoted in a *Los Angeles Times* article by Alina Tugend saying, "In *Chicago* light functions almost as another character. It not only leads the audience from reality to fantasy, but also makes the film's myriad moods— from joy to greed to abject loneliness—resonate." Eisenhauer continued, "We apply the timing to make the lights physically undulate and move as well as shift up and down. It creates a visceral experience for the audience."

The vast demands of movie lighting are from an imaginary world compared to working in a limited studio space, but the purpose of many techniques overlap. "It's all about style . . . to communicate atmosphere," said designer Peggy Eisenhauer, adding that lighting can make a scene look more lonely or seem more confusing. We individuals, in turn, can apply light for various forms of visual appeal.

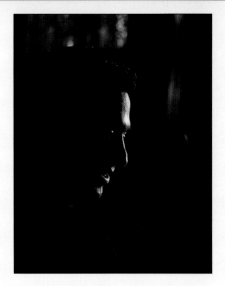

One interpretation of moody movie lighting is strong edge lighting with almost no background detail. Imagine the man as a character pondering a problem with someone out of the scene waiting for his response. If you were viewing the movie, you would feel that minimal lighting boosts the suspense.

Camera Equipment

Cameras

The type of photographic equipment you use and its quality does mat-
ter, but there's no brand name that has a monopoly on versatility or
lens sharpness. Whether you buy your gear new or used is your busi-
ness. It's more important to be comfortable with what you own so it
works smoothly for you. Reliability is a necessity, but try not to spend
money on features you don't need. The pictures you shoot are the
objective. When you show or sell pictures, people may ask what cam-
eras and films you used, only because they want to validate their own
equipment, or change to yours. Remember, it's your skill that controls
cameras, lighting, and composition. Even so, it's often worthwhile to
ask advice from more experienced photographers.

Film Cameras. *35mm Single-Lens Reflex (SLR) Cameras.* Single-lens
reflex cameras are ideal for portraits and product photography because
what you see in the finder is almost exactly what you get on film. I say
"almost" because most finders show only about 95 percent of what's
recorded on film to allow for the cropped edges of machine-made
prints. SLRs also offer the pleasure of switching between many avail-
able lenses. More expensive cameras are often heavier, though weight
might not matter when using a tripod. Put a heavy camera around

SLRs also offer the pleasure of switching between many available lenses.

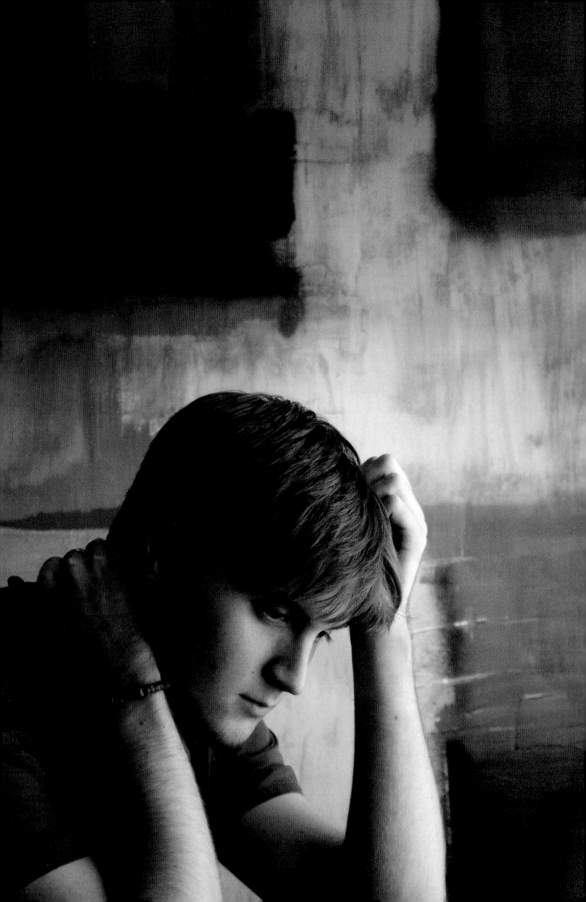

Right—This, like most of the pictures I made for this book, was taken with a 35mm SLR and my favorite 28–135mm IS Canon lens. In my borrowed studio, the main AlienBees electronic flash in a softbox was positioned next to the camera and a few feet higher. Electronic flash aimed into an umbrella was positioned off to camera left, and a third flash was adjusted to a lower power setting and focused on the background behind the mother and child. Flash is ideal to freeze children's and other people's movement. *Facing Page*—This image was photographed by Brian King, a professional portrait photographer who is an expert in photographing high school seniors. While he photographs some in a more conventional style, Brian also enjoys shooting creative experiments like this (and others in chapter 10). The main light, a softbox, was placed at about 90 degrees to camera right. A Fresnel light (named for the circular pattern in its lens) illuminated a unique hand-painted canvas background.

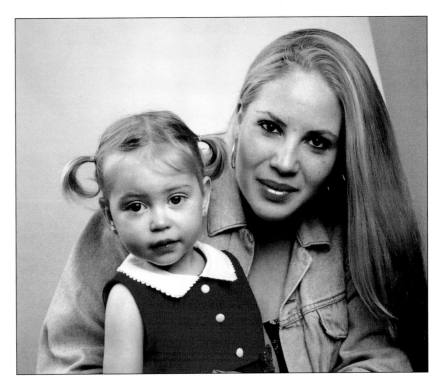

your neck, on the other hand, and it can be tiring. Happily, many excellent 35mm SLRs are lightweight, and if you're starting or switching, a modern 35mm SLR can be a fine studio choice.

Compact or Point & Shoot 35mm Cameras. While lots of these include versatile zoom lenses, they also use window finders that see the subject slightly differently than the lens does, which is annoying for fairly close portraits. If you own a point & shoot camera you love, you might adapt to its lack of framing precision, but point & shoots have several insurmountable handicaps for studio photography: they lack shutter speed and exposure controls, and most have no way to synchronize with studio flash units.

Medium-Format Cameras. Most medium-format cameras are SLRs; a few are eye-level window-finder models. Medium-format cameras are more expensive than some 35mm SLRs, but they are popular with professional studio photographers. Their larger finder and film size ($1^3/_4$ x $2^1/_4$-inch, $2^1/_4$ x $2^1/_4$-inch, 6 x 4.5cm, and 6 x 7cm formats) are advantages, and camera weight on a tripod isn't a factor. This format is often chosen for nature photography in place of a view camera.

Digital Cameras. These are rated in megapixels (MP), and a camera with 3 to 4MP or more is suggested. "Mega" means millions, and the higher the megapixel rating, the sharper your enlargements will be, especially beyond 11 x 14 inches. Professional camera models offer 5, 6, and more megapixels, plus other bells and whistles that are expensive. Most digitals include adjustable ISO speeds, and some offer expo-

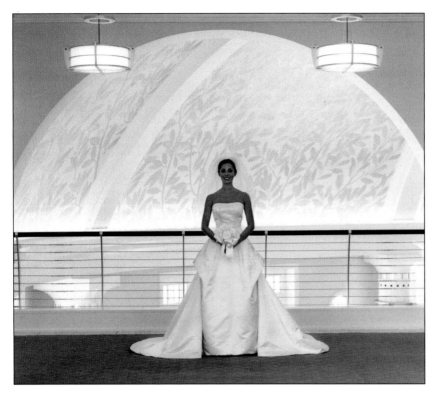

Roy Madearis created a striking design with this bride and a dramatic background. He posed her in the bright high key composition using two large umbrellas and shot with a Kodak 760 digital camera from a tripod to be certain it all lined up.

sure compensation for dealing with contrasty light. Digital's main advantage is instantly seeing what you just shot on a small LCD (Liquid Crystal Display) screen. This can be very handy in a studio when it's convenient to reshoot and make improvements.

Digital Point & Shoot Cameras. A majority of these are models with zoom lenses and window finders. The latter may not bother you because you can see the subject in the LCD viewer. However, while it's nice to view what you've just photographed, it can also break up your rhythm if you stop to look after each shot. Be sure that the point & shoot digital model you select allows you to choose shutter speeds and f-stops to use with studio flash. If not, you'll need a digital SLR.

Zoom-Lens Digital SLR Cameras. These models, made by major manufacturers, include nonremovable zoom lenses with through-the-lens viewing as well as LCD monitors. Many offer pixel ratings of 5MP and higher, as well as shutter speed and f-stop control. Zoom-lens SLR cameras offer many professional advantages, but be sure that the camera synchronizes with studio electronic flash.

Digital SLR Cameras. Single-lens reflex bodies can be costly, but if you already own a Canon, Nikon, Minolta, or Sigma camera, your present lenses may mount to that brand's digital body. This is a benefit for professionals, who can efficiently switch from film to digital bodies that include many exclusive options. A digital SLR can be an excellent choice for studio work.

A digital SLR can be an excellent choice for studio work.

Medium-Format Film/Digital Cameras. Serious studio photographers who want film cameras that convert to digital shooting should investigate the Bronica ERTsi, the Contax 645, the Hasselblad H1, and the Mamiya 645 AFD. Their 6 x 4.5cm formats are more than twice the area of 35mm, they are lighter than 6 x 7cm-format models, they use interchangeable lenses, and they are becoming professional favorites indoors and on location. Check company web sites for details.

Lenses

Zoom Lenses. These are almost everyone's favorites. Zooms in the 70 to 150mm range (or the 35mm equivalent when using a digital camera) are recommended for portraits, products, or still lifes because they can "draw" faces and other subjects without distortion. Test this for yourself by photographing a head & shoulders portrait at 70mm and frame the same approximate image at 135mm or 150mm. Optical distortion should be evident with the shorter focal length. Also consider lens weight when you buy, because lighter models will be more convenient to carry on outdoor photo adventures.

Single-Focal-Length Lenses. When photographers choose a single-focal-length lens it is often because its maximum aperture is f/2, which is handy for available light shooting. These lenses cost as much or more than zooms, and their versatility for portraits and products is limited. The presumption that single-focal-length lenses are sharper than zooms has mostly been dispelled. A zoom lens's widest aperture is usually f/3.5 or f/4.5, which is all you'll need with studio lighting.

Films

Color Temperature. Light is described in Kelvin (K) temperatures. Temperatures that matter to us are 2900K for room (indoor) lights; 3200K and 3400K for photoflood and quartz hot lights; and 5500K or 5600K for electronic flash. The latter are also the color temperatures of sunny daylight.

Color negative films and most slide films are made to match daylight and electronic flash but need to be filtered for hot lights or else they are noticeably warm-toned. Pictures shot on cloudy or rainy days or after dusk when the Kelvin temperature goes to about 8,000 are blue-tinted.

Kodak Type B Ektachrome (ISO 40) is made to match 3200K and 3400K flood and quartz lights. It is mainly used in the studio for still-life and product photography, because it usually requires slow shutter speeds with apertures such as f/11 and f/16.

. . . lighter models will be more convenient to carry on outdoor photo adventures.

Film Speeds. The most useful speeds in 35mm or 120 medium-format sizes are ISO 100 and 200, as they provide fine grain and sparkling colors when properly exposed. In the studio, where you can control illumination levels, an ISO 100 or 200 film is plenty fast. ISO 200 is okay for pictures taken with hot lights (floodlights or quartz plus a correction filter), but ISO 400 film may be more practical with slow shutter speeds to get sharper portraits. When using quartz lighting plus a color correction filter, keep in mind that the filter reduces ISO speed by more than 50 percent.

Digital Equivalent Film Speeds. Digital cameras don't use film, but their ISO ratings are equivalent to ISO film speeds such as 100, 200, 400, and 800. Slower speeds yield better digital image quality, and speed can be changed between exposures, which can be quite useful—especially when light levels become dim or quite bright.

Negative Films. Negative films are very popular because they can be enlarged, and the resultant prints can be scanned, digitally enlarged, and edited via a digital imaging program. Additionally, they offer more exposure latitude than do slide (transparency) films, meaning exposures that are slightly off the mark will not significantly affect the quality of the negative and resultant prints. Most of the portraits I took for this book were made with ISO 200 negative films.

Slide or Transparency Films. Only a limited number of pros and advanced amateur photographers shoot slide films anymore. They require more exposure precision than do negatives, and slide processing labs are available only in larger towns.

> Digital cameras don't use film, but their ISO ratings are equivalent to ISO film speeds.

The Roy Madearis Studio has a wide reputation in Texas for building sets where children play roles to distract them. Once the kids are occupied, Roy makes pictures using a curving Larson softbox that's hung from the ceiling.

Filters

Primary Filter Needs. Filters alter the color of light that reaches film in the camera and can also be used to create special effects. For studio work, you may only need filters to convert the light to match your film.

- The 80B filter corrects flood and quartz light for use with color negative films. The filter also reduces light intensity so ISO 200 films become ISO 100 and require slower shutter speeds.
- The 80A corrects artificial light for use with daylight slide films.
- Other than keeping a UV or 1A skylight filter over your camera lens to protect it, other filters for studio use could be a diffusing filter for portraits and special effects filters for more pizzazz.

Filtering Lights. For special effects, flash can be tinted warm or cool with colored gels, which are available in sets offered by most of the major flash manufacturers. Check manufacturers' web sites and photographic supply catalogs.

Digital cameras don't require filters to color balance the light. Images are recorded on memory cards and are transferred to your computer. An array of pictorial, color, and form variations are achieved via programs like Photoshop.

Tripods

Many tripod brands and sizes made by various companies are advertised in photo magazines and on the Internet. Size and weight are important considerations. For 35mm film or digital cameras a four- to five-pound tripod that extends about six feet high should be quite adequate for studio use. For a medium-format camera, consider a heavier tripod, but take your camera to the store and decide which size tripod works best. Also try several types of leg locks to discover what you prefer. Prices vary considerably.

The way the camera is attached to the tripod is also important. Some tripods are made with one or two small handles that are used to adjust a small camera mount. These handles often get in the way, so a type of mount called a ball mount is preferable. This is a type of universal joint that allows you to manipulate and pivot the camera conveniently with a few tripod adjustments. Indoors or out, I consider a ball head essential for composing photographs more easily and meticulously. Note that some models of tripods come equipped with a ball head. If this is the case, try out the head to make sure it functions as you like. If the tripod you want has a head you dislike,

For this portrait I placed a softening filter over the camera lens to slightly diffuse image sharpness. As you will see in future pictures of Stephanie, she didn't need diffusion—but some faces do. The main light was a softbox placed slightly to camera right; a fill-light flash was fired into an umbrella at camera left to brighten her hair. The latter spilled just the right amount of light onto the fabric background.

Top Left—*A father, mother, and two teenagers look very comfortable by window light that Brian King uses to excellent effect. This is not typical studio lighting, though there was a softbox in front to brighten the foursome.* **Above**—*For years I've used a Bogen tripod, one of several brands favored by professionals. Tripods are made in many sizes, the smallest for portability and the largest to assure stability for heavy cameras. This shows the built-in ball head of the Bogen model 724B, which has been quite steady for studio work with my SLR. The tripod closes to nineteen inches and weighs three pounds. Its legs are held firmly in position by lever locks.*

Advertising and corporate photographer Robert Rathe did this charming portrait of recording artist Sharon Dennis for a CD cover. He used a light bank at camera right with a reflector at camera left. Slight fill light was used on the background. This image was a digital capture.

ask if it can be removed and replaced with the one you prefer. If the original head can't be removed, find out whether a ball head can be mounted on it.

Last Words

Photo equipment can be seductive, so get involved with care. No matter how alluring cameras, lenses, tripods, etc., are, the best studio pictures are made by creative concentration on lighting, posing, composition, and often persuasiveness. My seven-year-old Canon A2 is no longer a top-of-the-line camera, but it's got more options than I need, and it's always been reliable.

PHOTO PREVIEW

Portrait examples in this and other chapters lead up to chapters 7 and 8, which are devoted to portrait and still life photography. These two pictures illustrate the contrast in pictorial approaches a studio makes possible.

Cameras and other equipment are partners in reliable lighting techniques. If someone asks what equipment you used for specific pictures, ask them to critique your photography. Then answer their query if you wish.

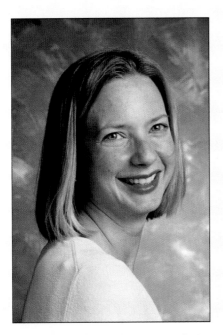 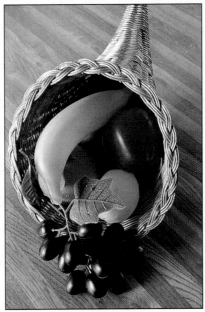

Left—In my living room, temporarily converted to a studio, I hung a handsome background from aluminum poles (called Polecats) tensioned between the ceiling and floor by springs. The model was lit by an Alien-Bees 800 flash unit (320 watt-seconds [see page 36–37]) in a softbox at right, slightly higher than her face. On the background was a 600W quartz light mounted on a low stand pointed up at 45 degrees. The softbox was centered so no fill light was needed. The aperture was f/11, and the shutter speed for proper background exposure was $^1\!/_{30}$ second. The portrait was exposed at $^1\!/_{3200}$ second by the flash. Right—The background on a table was a sheet of patterned floor covering. The cornucopia with artificial fruit was lighted from the right-front by a softbox, inside of which was a 200WS flash unit. The light was about six feet away, and a white reflector gently filled the shadow side at left. Floodlights and quartz lights are also good for still lifes.

Studio Lighting Equipment

Tungsten Lights

Tools and Techniques. Studio lighting is probably more challenging than finding the right outdoor light. We often need patience to wait for daylight we like, but in the studio we experiment to find the right light for people and still lifes—including products. We have to learn the nuances of studio lighting and must become aware of how its variations affect faces, figures, clothing, objects, etc. We discover the versatility of lighting equipment as we learn how to control its direction and brightness. We understand more about shadows and how they can be softened by reflectors, umbrellas, or softboxes.0

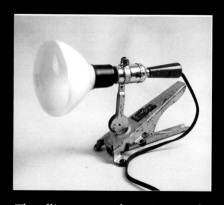

Lighting hardware is described in this chapter. Accessories are described in chapter 4. Try not to go overboard buying lights and modifiers (like umbrellas, reflectors, softboxes, etc.). (The latter are devices that are used to change the quality or spread of the light source, thus making portraits more flattering and products more appealing.) Practice with a minimum of equipment at first until you know what you want next. For example, economical off-white cardboard or foamcore reflectors are available for a few dollars.

The alligator-type clamp is versatile; it clamps to light stands, shelves, etc. The socket, handle, and wire are from a hardware store, and the reflector flood is a General Electric EAL 3200K. To carry it, fold the clamp and wrap the cord around it; be sure to pack the bulbs separately.

Hot Lights. Beginning photography students in most schools learn their first lighting techniques using floodlights (also called photo-

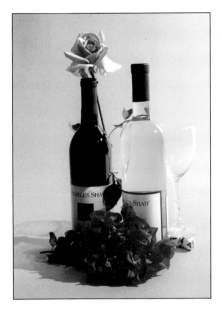

This is a preview from a series of still life images featured in chapter 7. Hot lights work well with still lifes because you can easily see just what the light does, and there's no subject movement. The main light at camera right was a small spotlight (shown on page 38), and a quartz light and a white reflector served as fill on the left. I placed an 80A filter over the lens to correct the color of the light for daylight-balanced color negative film. Practical and exaggerated lighting effects will be explored in chapter 7.

floods or tungsten lights) and quartz lights. In use, these lights get very hot, hence their nickname. Hot lights are favored over flash as you learn lighting because they make it easy to see what highlights and shadows are doing to a subject. While studio flash units include modeling lights (tungsten bulbs that provide photographers with a preview of what the flash will do), they are weaker than regular photofloods. Another reason hot light equipment is popular is it can cost less than studio flash. Check catalogs and web sites to make price comparisons.

Floodlight Bulbs and Reflectors. One type of economical hot light is a photoflood bulb in a bowl-shaped metal reflector mounted to a light stand. An alternative is a reflector flood bulb in a socket with a handle, electrical cord, and clamp. These bulbs are rated at 250W or 500W. Choose those with a color temperature of 3200K, because they're easier to find and last longer. Using color negative films, place an 80A filter over the lens to convert 3200K to 5500K to match the film. The bluish filter cuts light intensity in half so ISO 200 film, for example, becomes ISO 100. If shutter speeds then become too slow, switch to ISO 400 film. With your camera on a tripod, only image sharpness may be at risk when your subjects don't hold still. When in doubt, take extra exposures as insurance against subject movement.

Quartz Lights. Quartz bulbs within reflectors are units you mount on a light stand. They are more compact than photofloods, last longer, and are brighter. Bulbs are rated 3200K and are made in 600W and 1000W models. A 600W quartz light reflected from an umbrella offers more light when using an 80A filter with daylight films than a 500W floodlight would. Both light types get very hot, but minimum heat is transmitted to subjects three or four feet away. Quartz bulbs are more expensive than flood bulbs but are worth it.

ADVENTURES IN LIGHTING

Point a hot light at someone or something and you will easily see what it does. Do it often, and you will discover what people and things should look like, meaning attractive, dramatic, pensive, cool, etc. Still life images and product shots need to look smooth, especially to be salable. So get acquainted with tungsten lights; vary their direction and adjust their brightness by reflection or diffusion. Trial and error becomes a constructive teacher. With a digital camera, you see the results immediately, but film can be developed and printed in an hour, so you can still study your lighting techniques quickly.

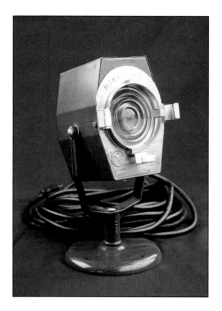

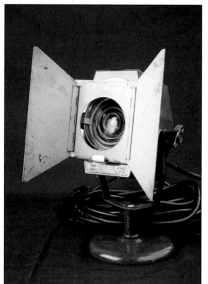

Left—This working vintage spotlight is rated at 200W, and its light is slightly warmer than 3200K. A spot is valuable for still life images or product shots because its light beam can be narrowed to accent a limited area. **Right**—*Adjustable metal flaps called barn doors were added to mask light at the edges. A metal tube called a snoot can be inserted in front of a spotlight to further narrow the light.*

You can buy photofloods and quartz lights separately or in handy kits with stands, umbrellas, cases, etc. Check them out online or in various photo suppliers' catalogs (see the resources section on page 120). JTL calls theirs *constant* lights and supplies them in 500W, 700W, 1000W, and 1200W. Each includes a cooling fan.

The JTL Corporation also offers a Web-Lite kit for still life images or fairly close portrait photography. In a fitted case are two Digi-Lites with reflectors that accept 250W tungsten-halogen lamps rated 3200K with three power settings. Included are two light stands and two 18 x 18-inch softboxes made of heat-resistant fabric, a first for hot lights. Check hot lights at photo supply shops, in magazine ads, and on the Internet.

> . . . a spotlight can be handy because you can focus the light.

Spotlights. For photographing still life images or products, a spotlight can be handy because you can focus the light. Spotlights are hot lights with a lens in front that reduces the spread of light to more of a beam than a flood. The light can also be masked with revolving metal masks (called barn doors) mounted in slots. A spotlight used from an angle behind a subject to light her hair is called a *hair light*.

Electronic Flash

Watt-Seconds (WS). This term is used in equipment ads and literature to define the amount of electrical power discharged with each flash. While the actual amount of light produced for a given number of watt-seconds can vary depending on a unit's design, the term *watt-seconds* offers a reasonable guide to comparing flash unit light output. However, exposure measured with a flash meter is a more practical way to make studio unit comparisons. (Describing their units, Paul C. Buff

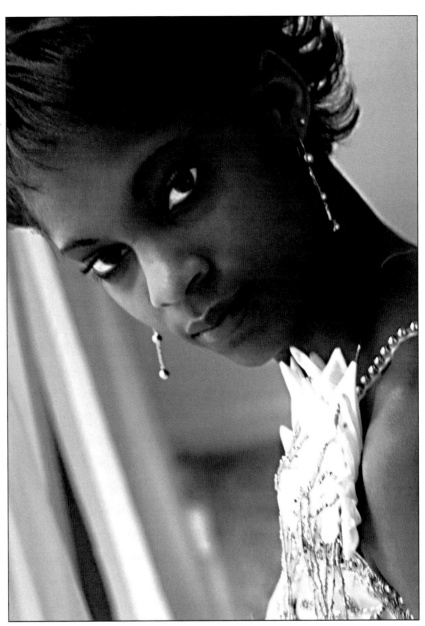

Above—Peter Gowland took this portrait of his daughter Ann as a Pilgrim many years ago. The beautiful image was not lighted with modern equipment but was created with two #5 flash bulbs, which were commonly used in 1950s studio lighting. The key light was slightly above the camera, and a second light brightened the background behind Ann.
Top Right—*Another typically effective composition by Brian King, who has angled the subject's expression to greet the viewer while the rest of the picture helps support the whole.*

Inc. lists "effective watt-seconds" and "true watt-seconds." Contact them for a full explanation.)

Studio Flash. These versatile flash units are a necessity whether your studio is at home or in a separate space. They are more powerful light sources than most hot lights or camera-mounted flash units, and you need their higher output because only half of it is reflected from the modifiers normally used with these sources, like softboxes and umbrellas. Studio units are available from 100WS up to 1600WS plus. Flash power can be adjusted to fractions of full power, which is handy for photographing close subjects or for fine-tuning the main, fill, and background lights. Typical studio units include a modeling light, which gives an approximate idea of what the flash will look like.

Modern units include a built-in slave unit, which causes the light to fire when another flash is fired. I use a small Sunpak on-camera flash aimed at a wall or ceiling to set off my studio units. No wires are needed between them. The small Sunpak doesn't affect the light from the studio units at all; it simply triggers them Studio flash units recycle in a few seconds, and their light is 5600K, equal to daylight.

Studio Flash Details. The most popular studio units are AC-powered monopacks, which means the flash tube, modeling light, reflector, and adjustable power unit are all combined. More expensive units use heavy separate power packs that are favored by large studios with

*The electronic flash units and accessories shown on this page were loaned to me by Paul C. Buff, Inc. The equipment has been efficient and reliable, and I like the fact that Buff sells directly to photographers. **Left**—AlienBees B-800 (320 true watt-seconds) comes in various colors along with B400 (160WS) and B1600 (640WS). All have built-in cooling fans. One B-400 and one B-800 would make a good starter set. **Center**—White Lightning was the original Buff brand. This is the X1600, which generates 660WS. Paul C. Buff also makes the X-3200 (1320WS), the UltraZap 1600 (660WS), and the UltraZap 800 (330WS). **Right**—Buff light stands extend from forty-two inches to thirteen feet.*

 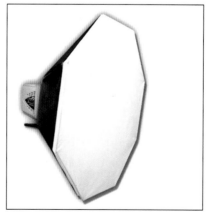 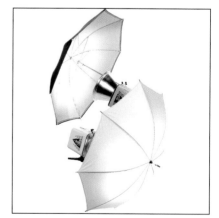

*Left**—Softboxes are available in 24 x 26-inch, 32 x 40-inch, and 30 x 60-inch sizes, all of which are typical studio sizes. **Center**—The Octabox is available in thirty-five and forty-seven inch diameters. **Right**—A variety of umbrellas in white, silver, etc., are available from thirty-two inches to forty-eight inches in diameter.*

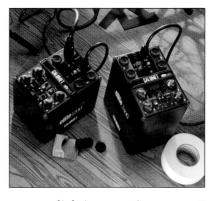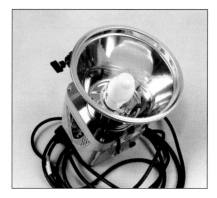

Left—*Electronic flash power packs by Calumet. Eight separate flash heads can be plugged into each of them. They are rated at 1200WS and 2400WS and are popular for powering large, custom-made softboxes.* *Right*—*Typical of studio flash, the AlienBees 400 has a modeling light (150W) in the center and a circular flash tube around the base of the reflector. An umbrella or softbox fastens to the unit with a fitted metal ring.*

. . . the effect of the flash is equivalent to the music played by an orchestra.

greater lighting requirements. For my portrait and product work, monopacks have plenty of punch and are pleasingly portable. Some monopack manufacturers (including Buff) offer accessory battery packs that make using your studio flash on location very convenient.

I found one of the trickiest aspects of using studio flash was getting used to the way modeling lights look on a subject, compared to how flash from the same position looks in a print. Modeling lights are relatively weak, and the highlights and shadows they create on a subject are usually somewhat pale. With experience you learn to interpret a subject seen by modeling lights as you expect to see highlights and shadows in the flash shot. Think of modeling lights as a solo violin or piano playing soft music. The "melody" from modeling lights is recognizable, but the effect of the actual flash is equivalent to the music played by an orchestra.

Camera-Mounted Flash Units. These can be adapted for only limited studio use, because light from the average unit becomes too weak when it's directed into an umbrella or softbox. Find out if your units are suitable by conducting a trial exposure using ISO 800 film(or your digital camera) with a modifier attached to the flash. Based on your results, you'll know if you can work with the f-stops needed for typical portraits. With direct flash, not softened, you might do okay with ISO 200 film, but diffused flash offers more professional images. While you're at it, try firing two flash units into an umbrella at the same time by plugging a slave unit into one. If the lights are close enough to the subject, you may do well, but eventually, a monopack will be more convenient and useful. A slave unit is a photo cell that triggers one unit's flash to fire at the exact moment light from another unit hits it. Slave units are built into studio flash units.

Meters and Flash Accessories

Continuous Light Exposure Meter. These are built into cameras for reading daylight or hot lights. The camera meters I've used have been

quite reliable, though I use exposure compensation in high- or low-contrast situations. Some camera meters include spot readings for faces and still lifes, but these should be used only with hot lights.

Flash Meter. A necessary studio tool, these instruments read the intensity of flash exposures and indicate the f-stop for an ISO you set. Most flash meters also read ambient light, so you can use them with hot lights and daylight.

Radio Remote Units. When you press your shutter release button, these units will emit a radio signal (either analog or digital) that triggers other flash units to fire. Essentially they are transmitters with receivers attached to each light, and with some models you can also remotely adjust flash power. Remote units are fairly expensive and are only necessary in a large studio or outdoors.

Guide Numbers (GN). These are determined by manufacturers mainly for use with portable flash units on cameras. You divide the distance from camera to subject into the guide number, such as 10 feet into a GN of 80, indicating f/8 as proper aperture. Since studio flash is frequently moved for various effects, guide numbers are impractical, and such work requires a flash meter.

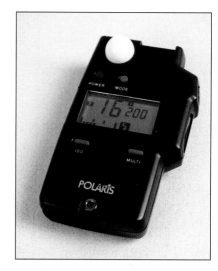

Set the ISO in a flash meter, place it at the subject, and when you flash one or more units it indicates the proper aperture for the picture. Most flash meters also measure ambient light.

TAKE IT EASY

Plan to buy lighting equipment in stages. If you don't have studio flash untis, basic training shooting portraits or still lifes can be done with three or four hot lights and two umbrellas. Once you're comfortable with these basics, you may want to add only two studio mono-packs to start. Additionally, purchasing two umbrellas or one umbrella and one softbox will further enhance your opportunities in the studio. For this book I arranged a loan from Paul C. Buff, Inc., of four flash heads, stands, diffusing and reflecting accessories, and other equipment. Some of this equipment is shown on page 38.

When I began shooting portraits and still lifes with my borrowed flash equipment, it was a surprising and refreshing change. I made many test portraits, and I studied my prints. My early mistakes were often due to misdirected lights and ugly dark shadows. Believe me, if you have all the lights you want at the beginning, you won't be ready to use them skillfully until your experience increases. So start buying lights and accessories sensibly and grow into studio lighting. If you want to buy your lights all at once, use only a few at a time until your photographic confidence grows.

A String Exposure Guide. A friend who shot magazine covers showed me this primitive yet practical technique. Attach a strong ten-foot (or longer) string to a studio flash unit and mark the string at one-foot intervals with a Sharpie pen or colored tape. Make a list of the f-stops determined for a specific film via a flash meter for each one-foot setting on the string. When shooting, extend the string from the flash to the subject, note the distance on the string, and consult your list of f-stops and power settings.

Companies that sell studio flash also offer accessories such as umbrellas, softboxes, light stands, diffusers, and other gear described in the next chapter.

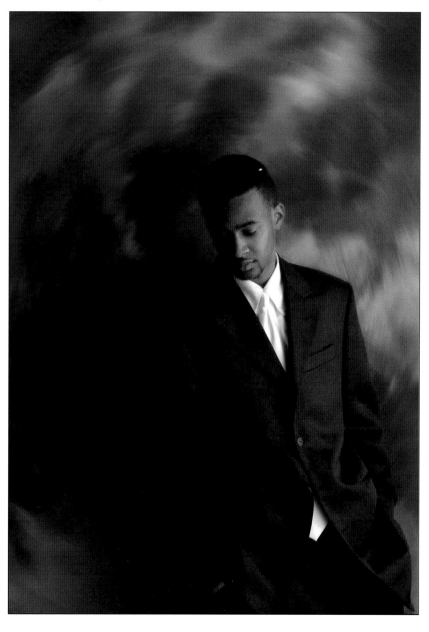

Above—*Many studio photographs are made in artistic black & white, such as this lovely fashion shot by professional photographer Roger Rosenfeld. It was taken with a Bronica 645 (6 x 4.5cm) using a 150mm lens. The main light was an umbrella flash with diffusing material over it, and fill light came from a large white card reflector. The background was illuminated by two very diffused flash units, one on each side, with barn doors to direct the light. The model's face was gently brightened in Photoshop.* **Right**—*The young man blends artfully into a kind of sky background in this strong picture by Brian King. One softbox, placed higher than the model and at 45-degrees from the right, helped create a moody portrait.*

Modifying Light

Studio photography offers multiple choices for your pleasure and enlightenment—pun intended. Like all worthy skills you've learned, lighting can be demanding, but it can also be exhilarating. Lighting styles depend on how you use available equipment plus your feelings about how people or things should look. With experience, you can control the whole process of creating highlights and shadows. Lighting examples have been included in all chapters, and in-depth demonstrations begin in chapter 6. Now we'll consider accessory equipment to help make your lighting look more professional.

Hard Lighting

Hard light is created by flash, floodlights, or quartz lights that are aimed directly at a subject and not modified by an umbrella, softbox, or other type of diffusion device. Unless it is diffused by clouds or otherwise softened, the sun is our universal hard light. Shadow edges from hard light are sharp, and the image will have high contrast unless the shadows are lightened.

We know how full sun makes hard shadows that cause people to squint. Outdoors we turn subjects' backs to the sun and soften shadows with flash fill or a reflector. In a studio, when faced with unattrac-

The sun is our universal hard light unless it's diffused by clouds or is reflected and softened.

Left—The first of a series to show a transition from hard to soft lighting. All of the portraits were taken with studio flash, and for this one, I added a single umbrella at left. It's an intriguing picture, but with one side of the subject's face in deep shadow, it's hard lighting. **Center**—Monika turned her head, and I placed a softbox at the left and forward enough to light some of the shadow side of her face. Because of the contrast between light and darker sides, it's still hard lighting, but the light on her hair at right softens the effect. **Right**—Another hard light example with a single softbox at right. Dark shadows are dramatic, but the light–dark contrast divides Monika's face awkwardly.

Left—This is a pleasant one-light portrait with a softbox at left. Subtle shadows on Monika's face are pleasing, and the lighting is soft. A background light would have been more conventional, and agreeable too. **Center**—Now the main light, a softbox, is at 45 degrees on the right, higher than Monika's head. A second flash was fired into an umbrella at the left to fill shadows. This sort of soft lighting is usually flattering for people pictures. **Right**—Soft light from a softbox directly opposite Monika's face is just right to illuminate her appealing expression. A hair light at left would have helped, but I didn't use it or a background light to accentuate the quality of light possible in a one-light arrangement.

tive shadows from an unmodified light, we use a second light, a fill light, to brighten shadows. If the second light is also unmodified (not softened), the subject may be well defined but not very pleasing. See for yourself. Light someone with one direct light (not softened) in front at 45 degrees and take a picture. Add another light to brighten the shadows and take another picture. Is the quality of the light unflattering? For most portraits I feel that hard lights can be downright unfriendly.

Softer Lighting

Lighting in a studio is quite controllable, and fortunately there is equipment to soften it and eliminate harsh shadows when that's your goal. I feel that diffusing hot lights or flash is just as integral to getting good results as where lights are placed. Most portraits, still life images, and product shots by professionals are created with diffused light. So let's discuss types of diffusion to increase your pictorial success.

Reflectors and Fabric. Reflectors can make a photographer's job easier, as they can be positioned where a light might not fit. Here are some suggestions.

- Illustration board makes a good reflector when cut to convenient sizes. To carry it easily, score it and tape the folds. White is efficient, but check out pale, warm colors that are kinder to faces. While you shoot, ask someone to hold the reflector, or rig it between two light stands with tape. Hold a reflector yourself for small subjects, and expose via a self-timer.
- Foamcore is lightweight and doesn't buckle like illustration board may, but it's usually white and, as you can't fold it, larger sheets are difficult to carry.
- A few layers of gauzy fabric mounted on a frame makes a pleasant reflector, and if it's thin enough, this material can be a good diffuser for flash. Photoflex makes a handy cloth diffuser that attaches to a folding frame.
- Several companies make reflectors in portable sets including white, silver, and gold.

Umbrellas. For many studio applications, it's better to soften light with a modifier that attaches to the light rather than a reflector. One such device is an umbrella, a unit that opens and closes like a rain umbrella and costs less than a softbox (the other common light-softening device).

Top—The shadow under Allison's nose indicates where a flash in a softbox was located—above her head and aimed straight down. Reflected light from a second flash on the background softened the shadow under her neck. Fill light could have brightened her neck, but it wasn't necessary. *Above*—Is the light soft or hard? Actually, it's in between. With umbrella flash at the left and no fill light on Allison's face, this image shows that shadows don't always have to be brightened. A separate flash covered the background. Sometimes umbrella and softbox lighting can look similar.

As you can see in the image on page 38, when you use an umbrella, the light unit is pointed into the center of the umbrella, which then bounces the light back onto the subject. Unlike softboxes, umbrellas can be used with either hot lights or flash units. With hot lights, the umbrella will be set up by clamping its stem onto a light stand along with the light. With studio flash, the umbrella's stem will be secured through slots in the flash reflector. When used with hot lights, begin by positioning the umbrella four to six feet from your portrait subject. With studio flash, the umbrella can be placed farther away depending on the unit's output.

Umbrellas range in size from thirty to forty-eight inches wide. Another difference between umbrellas is the color of the interior.

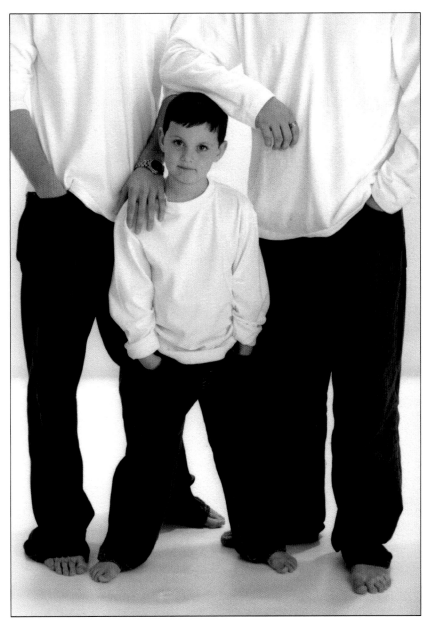

Above—*This Larson Reflectasol clamp fastens to a light stand to hold and position the stem of an umbrella, primarily with hot lights. (Similar clamps are also made by other companies.) I took the picture with one softbox, which was placed at the left.*
Right—*In the course of photographing high-school seniors, Brian King finds novel ways to pose them, in this case with a little brother. Using a large softbox in front and another behind the group gives them individuality.*

Umbrellas with white and silver interiors provide brighter light on a subject. A gold lining warms the color and can be flattering. I've enjoyed using white umbrellas for years as main and fill lights with both flash and hot lights.

Softboxes. Softboxes are better light diffusers than umbrellas because they produce softer light, and larger types spread light nicely. They are made in rectangular and octagonal shapes that are mounted on a flexible armature. Available sizes include 24 x 36 inches, 32 x 40 inches and 48 inches octagonal. Softboxes are designed mainly for use with electronic flash, which is cool in temperature, whereas a hot light might damage the average softbox. The softboxes I use are attached to Paul C. Buff AlienBees and White Lightning units via a "speed ring" on which the softbox can be revolved without moving the flash. Other companies use a similar ring configuration.

Backed with a black cloth, a softbox is lined inside with white fabric, and a translucent piece of white fabric runs inside in front of the flash. The outside front of a softbox is also translucent fabric, so reflected light is diffused through two layers, making softboxes great for portraits.

Large custom-made softboxes that house several flash units are common in commercial studios. They may be six to ten feet long and are usually suspended from the ceiling. Loaded with multiple flash heads, custom softboxes can produce enough light to photograph automobiles or interior sets.

Exposure Considerations. The intensity of any light reflected from an umbrella or softbox is reduced by about half when you diffuse it, so a shutter speed with hot lights may be relatively slow, such as $1/15$ or $1/30$ second, at ISO 200. You can use larger lens openings, but depth of field decreases according to how close you focus. Switching to ISO 400 with hot lights helps provide faster shutter speeds so portrait subjects don't have to sit like statues.

When an umbrella or softbox is used, a photographer's aperture options increase with studio flash because it generates more light than floods or quartz sources. Big smiles freeze easily at $1/1000$ second. These are reasons why studio flash units are preferred by professionals and smart amateur photographers.

Singer Jean Pace was lit by Peter Gowland with a single thirty-six-inch Larson softbox (inside of which was an 800WS Norman strobe) placed slightly to camera left. No fill or background light was needed because Peter wanted a strong portrait effect.

Backgrounds

. . . use a wide variety of backgrounds made from wallpaper, painted walls, and fabrics.

Fabric, Paper, Etc.

A background can be fashioned from hanging sturdy paper or fabric, and there are many choices. I usually like fairly plain portrait backgrounds that do not visually compete with the subject being photographed. For variety I switch from blue to pale yellow to pale tan background papers or fabrics. I've also used red and green when brighter colors were appropriate. Feel free to use a wide variety of backgrounds made from wallpaper, painted walls, and affordable fabrics—but try to avoid distracting designs. Fabrics are made in various widths, so consider wider ones for groups. You could also paint one or two 4 x 8-foot sheets of plywood in different colors on each side and mount them on a movable base.

Seamless Paper

Rolls of heavy background paper (available in many colors in six-, nine-, and twelve-foot widths) are traditionally used in commercial photo studios. These papers can be taped to a wall or suspended from a pole and extended to the floor and under people or products for a seamless appearance. (At the end of this chapter, you'll find instructions for building a rolling background rack.) When footprints mar the

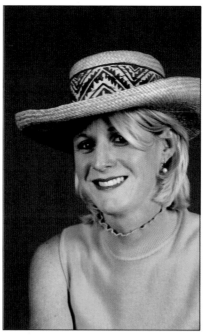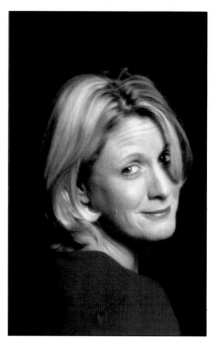

Left—This is the first of a series of three poses and three backgrounds, which demonstrate portrait variety. Against a green background, Stephanie was lit with one softbox slightly higher than the camera and to its right. Another light from an umbrella accented her hair and spilled onto the background. I used a diffusion lens for this as an experiment. *Center*—A softbox is a favorite light diffuser in the studio. Here, Stephanie was lit by a large octagonal one placed low at left to reach under her hat. It also brightened the red background. *Right*—This is soft lighting with a dark twist. Stephanie attractively peers over her shoulder with the softbox almost centered higher than the camera. I didn't light the background in order to show how it can be used for dramatic contrast.

Photographers can choose from a wide variety of backgrounds in order to add another level of creativity to their images. The sample backgrounds shown here are from the Denny Manufacturing Company.

paper, that section is cut and trashed. Check photographic supply stores.

Custom Backgrounds

There are dozens of plain, decorative, scenic, and rich-looking backgrounds made just for use in photography studios, many of which can be found in the popular Denny Manufacturing Company catalog. I became more familiar with their diversity of patterns and themes when Denny loaned me a few custom backgrounds. Their usage is noted in several photo captions in various chapters.

Denny background categories include Old Masters, Solids and Textures, Scenics and Interiors, Muslins, and Specialty backgrounds.

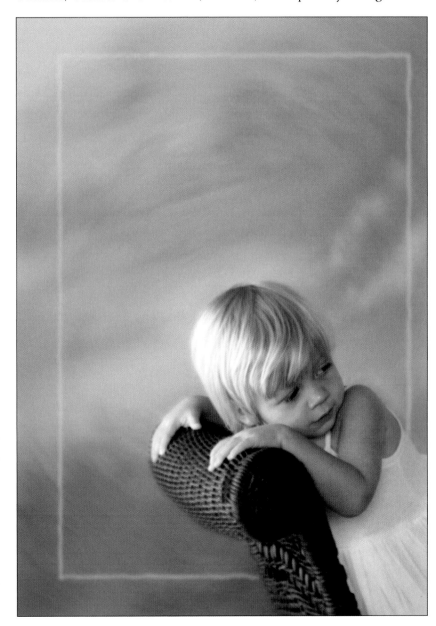

Brian King shot this captivating portrait with one studio flash in a softbox at camera left, plus a large silver Larson reflector at camera right, far enough away for subtle fill light. In Photoshop he enhanced the colors in the hand-painted background, then created a thin-line frame and softened it. Brian enjoys enhancing portraits in Photoshop to improve visual appeal.

These are canvas backgrounds, which are more expensive than other fabrics you can buy, but canvas is more durable. Special background designs like these can give your pictures an added distinction.

A Rolling Background Rack

Since my temporary studio was in a friend's larger one, I didn't wish to hang backgrounds on his walls. Instead, I built a rolling rack and taped a piece of seamless paper to the top; for variety I draped fabric or canvas over the paper. The rolling rack is portable, which allows me to angle it as I see fit or to wheel it opposite a window. It has to be partially taken apart for storage, unless you have space with a high enough ceiling.

The rolling rack is portable, which allows me to angle it as I see fit.

Using a rolling background rack like this one opens up new opportunities for great shots when working in limited space.

Materials Needed. A list of the materials needed to construct the rack appears below. The estimated cost of materials, depending on your source, will be $50–65.

Pine Lumber
- Top and bottom pieces, 1 x 4 inches wide, 7 feet long
- 4 upright pieces 1 x 2 inches, six feet long (*Note:* 6¹/₂ feet or 7 feet may be more suitable if you photograph many standing subjects)
- 3 outriggers 2 x 4 x 24 inches (*Note:* These supports are indicated by the three rectangular "floating" shapes in the diagram)
- 6 casters, ball or wheel shaped

Fasteners

- 8 1½-inch Phillips-head wood screws
- 6 ¾-inch Phillips-head screws
- 3 ½-inch bolts, 4 inches long
- Washers and nuts to fit ½-inch bolts
- 14 L-shaped 3 x 3-inch steel-angle iron braces

Assembly. Screw the top and bottom pieces to the upright pieces with 1½-inch screws. (It is helpful to "start" the screws by first making shallow drill holes.) Screw the L-shaped braces at the top and bottom on each side of the upright pieces, and to the top and bottom pieces with ¾-inch screws. Position the outriggers left, right, and center, and drill three ¼-inch holes in the bottom piece. Drill ¼-inch centered holes in each outrigger. Place a 4-inch bolt in each bottom piece hole with the washer at the top and through each outrigger. Place a washer on each bolt and fasten the nuts tightly to prevent outriggers from rotating. Note that the rack is not glued together. This makes disassembling it for storage or to transport it feasible.

Once the rack is assembled, coat it with a sealant or outdoor paint if you plan to use it outdoors. I did not paint mine because it was used only indoors.

Once the rack is assembled, coat it with a sealant or outdoor paint.

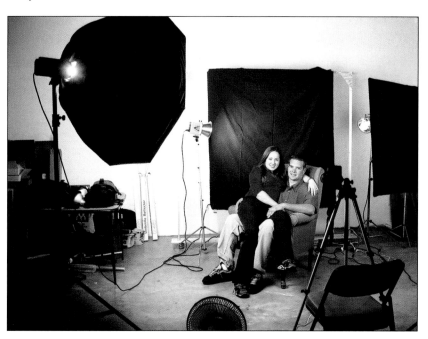

Here's the working area of my borrowed studio with the portable rack diagrammed on these pages. Old faithful umbrella and softbox lighting are prominent, as is the camera in the center.

Exposure for Flash and Hot Lights

Exposure should not be much of a problem in the twenty-first century. Autoexposure cameras, automated film and print processing, and computer photo printing are all designed to contribute to near-perfect exposures, especially with color negative films. If you use a nonautomatic camera that requires a separate meter, and your meter is reliable, exposure decisions are also relatively easy. The trick is to understand a few facts about contrast and exposure management, and that's the goal of this chapter.

Basic Metering

Light meters are programmed to assume that, taking into account a full range of tones from bright to medium to dark, the subject you are metering averages out to a tonal value that is equal in brightness to 18 percent gray (on a tonal scale where pure white equals 0 and black equals 100 percent). The reading provided by an 18 percent reading indicates accurate exposure based on the middle gray value.

While many subjects *do* average out to about this tonal value, many others do not (they are lighter or darker overall than 18 percent gray). In these cases, using the "normal" (suggested) meter reading will not provide a pleasing exposure. In such instances, you

Exposure is based on subject contrast plus the direction and intensity of light.

must manually compensate your exposure, as described below.

Alternately, you may purchase a gray card. This is a small piece of cardboard that is 18 percent gray (and some also have useful exposure information printed on them). By placing this card in the same light as your subject and taking a reflected-light meter reading off it, you will get the reading needed to render your subject correctly—regardless of how light or dark it is. This is ideal for both film and digital cameras and creates easy-to-print images.

Flash Meters

Flash exposure in the studio is easy with a meter. Just use it for a single session, and you'll marvel at its simplicity. Set the film speed and hold the meter at the subject, or place it in a stable position with the light-gathering

A special baby in a bright environment was lit by a large window in Brian King's studio. Reflectors at camera right feathered off the light to make the fill subtle. The result is a high key image with a palette of light tones and darker accents.

dome facing the camera. Set the meter for the film speed you're using, and pop your units without taking a picture. The meter will give you an f-stop readout to match the light intensity—and it is almost always right for color negative films. Consider bracketing exposures for slides.

Note: Most flash meters are designed to read ambient exposures too. If your camera has no meter, you can use a handheld flash meter in the studio and outdoors as well.

Exposure Compensation

Whether a subject is predominantly bright or dark, an exposure meter is programmed to average its tones to 18 percent gray. All light meters average the light in the same way as a result. Lots of bright tones cause a meter to recommend underexposure, and pictures with dominant dark tones tell the meter to overexpose. To ensure correct exposure in such scenes, you will need to use exposure compensation.

Exposure compensation counteracts the meter's tendency to achieve an 18 percent gray, and it is applicable to shooting with hot lights or flash. Most professional-grade cameras offer exposure compensation adjustments, usually in half stops. You make these adjustments on a scale in the camera finder and/or top readout.

When your subject is not "average" (it's predominantly light or dark in tone), proper exposure needs your loving attention. In such situations, bracketing your exposures will increase your odds of success.

High Key. *High key* is a term indicating a subject in which practically all dark tones have been eliminated. The lighting is usually bright and diffused, with shadows that may be shades of dark gray with black accents. High key photographs need minimal dark areas for contrast. Bright tonal differences are delicately separated to define the subject and create a bright mood, usually with reflected light. To shoot a high key scene, compensate by opening the lens or reducing the shutter speed a half or whole stop. For comparison, expose a frame normally, per your meter reading.

Low Key. Low key images have primarily dark tones. Shadow contrast created by lighting is okay, but be sure to light with restraint because the picture needs a predominance of dark tones to succeed. Accent a low key mood by using a dark background. As in high key, the tonal scale is limited, but do not overexpose. Using hot lights or flash, select an aperture that's one-half or a whole stop smaller, or select a shutter speed that is a half or a whole stop faster. This simple step will help you to keep the tonality and somber or mysterious mood in your prints. Imagine a dimly lit face with a black hat, minimum edge lighting, and a dark background. It's a low key portrait you might shoot for a creative kick.

It is important to remember that there are two parts to the creation of a high key and a low key image—the lighting that's used and the tones inherent in the pictorial elements (subject, clothing, back-

This setup was made to illustrate lighting a predominately dark subject with some bright accents. It was shot with quartz lights reflected into two umbrellas, placed at left and right for even lighting. The camera meter indicated f/11 at ¹/₄ second. I shot at ¹/₄ and ¹/₈. This image is the ¹/₈-second exposure on slide film, which has little exposure latitude. The meter averaged the mainly dark-toned subject and indicated overexposure to lighten the picture. I gave it one stop less exposure to retain its actual tonality.

HIGHLIGHT AND SHADOW DETAIL

An individual exposure can produce a fairly dark shadow and a fairly bright highlight in the same subject. It's your job to monitor exposures in order to achieve the detail you want in the highlight and shadow areas. Make a test series of a subject's face and bracket from two or three stops brighter to two or three stops darker. Be sure to keep film exposure notes. Machine-made prints from eight different negative exposures a half-stop apart may be fairly close in tonality, but colors in the prints may be slightly washed out (overexposed) or slightly degraded (underexposed).

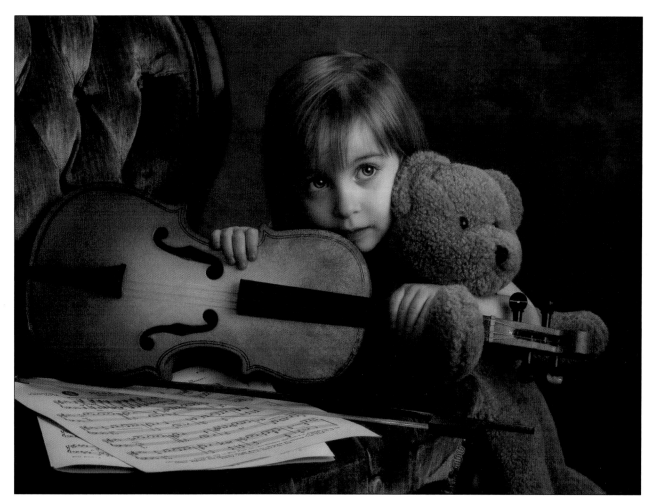

This beautiful narrative portrait by Frank Frost of Albuquerque, NM is a visual treat. The lighting and exposure are ideal, almost perfect— a word I rarely use. At right he placed a Larson Starfish curving softbox that wraps the light partially around the subject, and shot with a Mamiya 645 camera and a Stage One Lightphase digital back. It would be a worthy challenge for you to try and create similar smooth portrait lighting.

ground, and props). In fact, lighting technique and subject tonality are inseparable in creating these images. Experience shows that creating high and low key images requires lots of practice. You don't learn to modulate light well until you've seen a lot of good and bad prints.

Exposure for Different Media

The exposure settings you choose must take into account the characteristics of the media on which you've chosen to create your image. Not all media are capable of recording the same range of tones.

Negative Films. Color negative films are quite tolerant of one stop or more overexposure, which is ideal if you forget to compensate. These films are less tolerant of underexposure, so adjust the aperture or shutter speed accordingly. Black & white negative films have less latitude than color negative films.

Transparency Films. Transparency and/or slide films are more sensitive to over- and underexposure than either color or black & white negative films. Slight underexposure is likely to give you more brilliant colors with slides.

Digital Exposure. Photographer Brian King, many of whose portraits grace this book, told me, "Lighting for digital photography is very similar to lighting for transparency films. Though post-production manipulation is feasible, I suggest keeping your lighting ratios in check to control contrast, but I do the same for portraits and products when shooting film. I use a color chart or a gray card each time my light placement changes. I can use the 'luminometer' function on the digital camera's LCD screen to select the gray portion of the card, make a meter reading based on the percentage of gray, with 18 percent being right on the money. That doesn't necessarily mean lighting ratios are in line, so it's important to stay on top of your overall lighting scheme. In post-production I can at least check color accuracy."

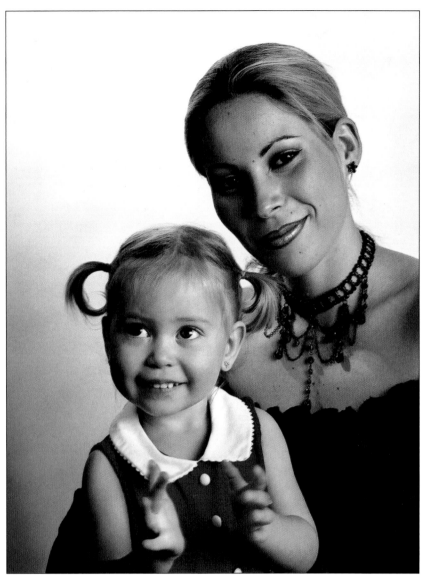

Learning how to set the white balance and other digital settings is important to image quality, but it's always consoling that tone and color corrections can be made via a computer program after shooting. Being able to see your lighting immediately in a camera's viewing screen is the big payoff.

Lighting Ratios

Exposure latitude and lighting ratios are related but different. *Latitude* is how much difference in exposure (from highlights to shadows) film can handle before suitable prints can't be made. A lighting ratio indicates the difference in the amounts of light that fall on a subject. Ratios like 2:1 or 3:1 state that the bright areas in the scene received two or three times as much light as the shadow areas.

So which ratios are more agreeable than others? It depends on your subjects and the pictorial effects you want. Lots of shadow can be

To create this image, I placed the flash, in a softbox, at camera right and slightly above their heads, and another softbox at left was turned down to faintly fill the shadow side. I metered the bright- and shadow-side strobes separately. Contrast here is medium high, but shadows are minimal. The flash meter was held in front of the subjects and aimed at the camera. My film choice was 35mm color negative film.

When I placed flash in a softbox at the model's left, with a weaker flash aimed into an umbrella at the right, and a hair light high from behind, I was not thinking about lighting ratios. The main light at left is soft, and I adjusted the umbrella light at right using the modeling light. The hair light separates the model from the background, which was not lighted separately.

moody, while lots of highlight area can be visually stimulating. Ratios are measured with an exposure meter for flash or hot lights. To determine the ratio in a scene, light and meter bright and shadow area separately, then compare the readings. For example, readings of f/11 for highlights and f/8 for shadows would indicate a 2:1 lighting ratio.

Once you understand lighting ratios, you may find them useful. I confess: I prefer to rely upon my observation of the subject. If shadows seem too dark, I can move a light closer or increase flash power. When an area seems too bright, I move the light farther away or decrease flash power. I decide what pleases me, but I make variations for diversity. Most studio flash units and some hot lights can be dimmed or brightened with a manual control, but it takes practice to evaluate what's happening. Practice comparing bright and darker areas to vary contrast. If your lighting is criticized and you don't agree, listen, learn, and hang on to your convictions when they satisfy you.

Lighting Advice

While shooting portraits or still lifes, it's typical to vary the lighting frequently. Later, edit your best prints carefully. If you're like me, you may enjoy your prints more the second time. I tend to be too critical at first look.

One suggestion is to shoot with a digital camera and inspect your lighting and pictorial results on the rear LCD screen immediately after exposure. Adjust the lights, recheck the exposure, and shoot again.

For film or digital, studio exposure is always a pleasure because you can modify your lighting and where and how to aim it (and how much to brighten or soften it). Done well, lighting feels good.

MONITOR YOUR PRINTS

These two prints were made from the same negative. The print on the left was too dark, and the model and I both preferred the lab correction, which is shown at right. When pictures seem poorly printed, take them back and ask for reprints. Automated film processing and printing is economical, and color is often accurate. When it's not, you owe it to yourself and your subjects to request reprints. One-hour photo shops charge more than send-away processing labs, but many are willing to correct print colors with your guidance while you wait.

Lighting for Still Lifes and Products

You may wonder, "Why cover still lifes before portraits? Isn't portrait photography more important?" Yes, it is, and making people look great with your photo skills may be more fun and could even become more lucrative. But there are several good reasons for tackling still life images first:

- You can learn more and faster about lighting practices by shooting bowls of fruit or makeup containers because you don't have to please them, they don't move, and you can concentrate on lighting techniques.
- You will grasp more quickly how to control one, two, and more lights by shooting inanimate subjects. When you move lights you will better understand what happens to form, shadows, and composition.
- Still life subjects don't become camera shy, and there is rarely an emotional connection to divert your attention.
- You can experiment with lighting arrangements without anyone complaining about the time. And you'll have less concern about messing up a few pictures if the lighting is disappointing. Still life subjects won't say, "You made me look terrible."

You will grasp more quickly how to control one, two, and more lights by shooting inanimate subjects.

• Shooting still lifes is excellent basic training in the studio. On your way to becoming an expert in lighting techniques you can learn as much from your mistakes as you do from your triumphs, without disappointing anyone.

Study the pictures in this chapter and try to emulate subjects and lighting you like. Consider the images you like best, and analyze why. Remember that personal taste and your sense of design play important roles in your visual decisions. Get involved for your own pleasure and edification.

Above—The aesthetic relationship of photography and painting is vividly revealed by this Roger Rosenfeld still life in the Van Gogh tradition. The composition is neatly designed, and the colors are harmonious. Roger created the photograph with a 4 x 5 view camera and transparency film. The main light above and to the right of the camera was a medium-size softbox; in front was a larger softbox for subtle fill. There's a faint painted texture on the background. Roger sent the picture to clients as a promotional piece. Right—Robert Rathe shot an array of coins for a General Electric brochure. He made a careful arrangement and checked it on the ground glass finder of his 4 x 5-inch view camera. A large softbox overhead was placed slightly behind the coins to backlight them. In front a piece of white foamcore reflected light for fill. Try photographing backlit coins yourself using a close-focusing lens.

Preparations

In this chapter there are progressive photographs of three still life setups. For the first series, I chose objects that relate in a random composition, not meant to tell a story. For series two, I used wine bottles, flowers, and a glass—basic still life subjects. In the third arrangement food was displayed informally and lit expeditiously. Also included later in the chapter are three outstanding still life photographs by Roger Rosenfeld, and two by Robert Rathe.

To shoot the still life pictures featured in this chapter, I created a temporary studio in my 25 x 25-foot living room. Furniture was moved, and several handsomely painted backgrounds loaned to me by Denny Manufacturing Company were suspended one at a time from two Polecats. These poles are tension-adjusted between the floor and ceiling with a third aluminum pole placed across them. I darkened the room with louvered blinds so daylight wouldn't affect color fidelity. The hot- light exposures averaged between $\frac{1}{8}$ and $\frac{1}{4}$ second on ISO

I darkened the room with louvered blinds so daylight wouldn't affect color fidelity.

Robert Rathe created this photo composition for an annual report. The client wanted to illustrate e-commerce capabilities. The computer monitor came from Robert's files, to which he added the client's logo (the circuit-board sphere), and he completed the design in Photoshop.

A company magazine cover was created by Robert Rathe in his studio. A "wall" of plywood was painted, and on the rack were hung a telephone linesman's hard hat and test phone. A window without glass was positioned high off right with a direct flash behind it to make shadows. At left Robert placed a 4 x 8-foot sheet of foamcore to brighten the shadows. The setup was photographed on 4 x 5-inch transparency film.

200 film. They are slow because an 80A conversion filter reduces ISO 200 to about ISO 75, which didn't matter because small apertures are routine for still lifes.

My Lighting Choices. Before moving on to each series, I should point out that I chose hot lights for two still life setups, because they make it easier to see what light does to subjects. (Studio flash modeling lights don't provide the contrast you get from 600W quartz lights.) Hot lights are a great way to learn studio lighting. As you later enjoy the blessings of flash, you will be better able to anticipate its nuances and versatility. Hot light experience makes you better prepared to use flash with people and things.

For my third short still life image series I strayed from hot lights to reflected flash because it was expedient for food shots. The heat from quartz lights might have wilted the lettuce. Professional food photographers prefer flash because it pumps out much more light than quartz bulbs, making smaller f-stops possible for greater depth of field. Actually, most pros use studio electronic flash for still life images for the same reasons.

The subject selection in the first series (next page) began with two pigeon eggs (in front) discovered in an abandoned nest at the edge of our patio. I added a painted ceramic egg, a chicken egg, and an onyx egg bought at a national park gift shop. To vary shapes, I included an Indian peace pipe from Pipestone National Monument, MN (where pink stone for the pipe bowl is cut from the earth), a brass goblet and

pitcher, and a few stones. These items had contrasting shapes and were grouped for an interesting composition.

Equipment. This first series and the second lighting demonstration were lit with a direct (neither reflected nor diffused) 600W quartz light, with another 600W quartz light reflected from a white umbrella and a small 200W spotlight (see page 39). These lights were chosen for their diversity. The spotlight uses an incandescent bulb and has barn doors (adjustable masks that control the spread of light) in front. My spotlight is vintage, and it's on a peculiar, short stand with no way to mount it, so I positioned it on two corrugated boxes and added thinner boxes to raise it. My spotlight is an heirloom, but newer ones on stands are available.

My quartz lights are compact 600W units mounted to light stands. One was aimed into a Lightgear USA umbrella from Paul C. Buff, the other was used direct. The quartz lights are rated 3200K, the spotlight was about 3000K. To correct their Kelvin temperature to match daylight-balanced print film, I placed an 80A filter over my 28–80mm Canon lens on a Canon A2 body. The filter works magically but reduces film speed about 60 percent, which isn't a problem when shooting still lifes with a tripod.

> A spotlight is more focused and good for still life accents.

Found Objects

It's hard to see some of the items in the first image in this series, which was made with only a spotlight at left (a rather primitive lighting approach). Contrast is dramatic, but pictorially the image is a failure because objects blend into opaque shadows. A less disappointing image could be shot with one floodlight aimed into an umbrella, but that comes later. A spotlight is more focused and good for still life

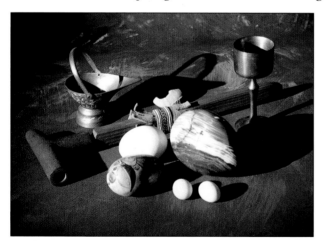 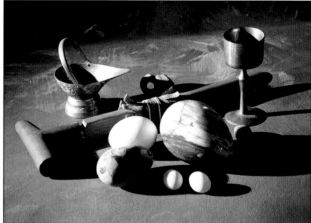

Left—*This first image in the series has dramatic contrast. However, pictorially, the image fails since the objects blend into the shadows.* *Right*—*Here the contrast isn't quite as harsh, but the shadows are still opaque.*

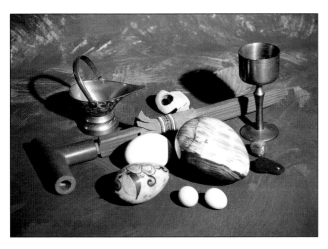 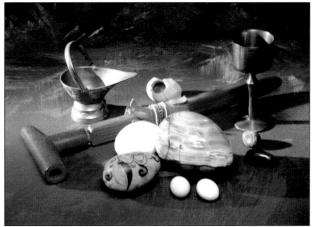

*Left—Shadows are smaller and more pleasing in the third image in this series. **Right**—In this image, fill-in light from an umbrella illuminates shadows and create a more evenly lit image. It's the best lighting solution yet.*

accents. Spots are prominent at stage productions, and I used one here for comparison with other hot lights.

A Word about Shadows. Shadows can be the key to successful or failed photographic lighting. Hard shadows become black holes in the first image in this series, but they do indicate form. In later versions of the image, softer, brighter shadows show better detail with more moderate pictorial contrast. You'll soon note that reflected or diffused light creates more artistic shadows. Shadows act like sundials in a picture; they show where lights were placed. Some lighting positions can also be noted by small reflections on glass or metal and in people's eyes.

The second image in this series (facing page) is a variation on the first with the spotlight slightly repositioned. A little of the harsh contrast is gone, but the shadows are still opaque. The background color is nicer, but some detail is limited yet. It's not entirely an aesthetically pleasing image, mainly because of the lighting.

In the above left image, the third photo in this series, the spotlight has been replaced with an undiffused quartz light at the right. It's one light with a horizontal reflector placed higher so objects are easier to recognize. Shadows are smaller and less annoying. The lighting is still harsh, but the picture is improved, though the composition doesn't seem pleasantly organized.

A bare quartz light is still at the left making shadows in the above right image, but there's softer light from a quartz unit reflected from an umbrella just right of the camera. The umbrella light started as a fill but became as important as the main light at left. The key light is most important and usually brightest, and the fill illuminates the shadows. In this case, both lights have about equal value, and it's the best lighting solution so far.

> Shadows can be the key to successful or failed photographic lighting.

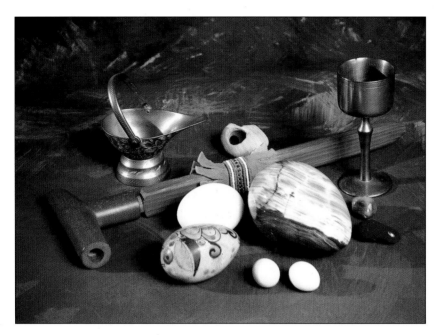



Here, contrast has mellowed for a much improved final image. Compare this photo to the first image in the series.

In the final image in this series (above), the main light comes from a quartz light–umbrella combination to the right of the camera. I held a white cardboard reflector (about 20 x 20 inches) above the pitcher to highlight it and some of the rear area. I call this "civilized" lighting. It's the smoothest configuration in the series. Contrast has mellowed, and the items are seen clearly. Compare this to the severe lighting mess in the first image.

While editing prints I found more that might have fit into this series, but they were too similar to others chosen. I mention this to encourage you to shoot every lighting variation you feel is worthwhile. A slightly different lighting arrangement may improve a picture and reward your efforts. Edit your prints and show just the best ones. Toss the failures, but store similar images for a while. This is part of the learning process.

Still Life for a Wine Ad

In the second still life series, I combined a light and dark wine bottle, a bouquet of bougainvillea, a wine glass, and the handle of a cheese knife, which is practically invisible, but I was enjoying myself and didn't notice soon enough. The composition is relatively simple. The background is another beauty borrowed from the Denny Manufacturing Company. A discussion on the lighting equipment I used to create this series appeared on page 62.

The spotlight, with a wide beam, was the only illumination for the first image's visual amusement with its elongated shadow. I imagined the composition as the background for a wine advertisement with ad

Edit your prints and show just the best ones. Toss the failures, but store similar images for a while.

copy in the blank spots. Had this been for an ad, however, I wouldn't have covered the name of the wine. If you don't have a spotlight, a quartz light or a single studio flash will produce a similar effect. The angled rose shadow at right indicates how the background was curved.

In the second image (lower left), the main light is now a quartz unit reflected from an umbrella at right front, with another quartz light and umbrella at left front slightly farther away. You can see that the light at right was closer because it washed out the shadow from the light at left. Not until I saw the prints did I realize that the glass had disappeared into the background in most of this series. I should have used a tinted glass.

What's the difference between the second (left) and third (center) image? In the latter, an umbrella light was high and to the left in front, and bottle shadows tell the story. The dark left background area is where the umbrella light ended. The glass shows up a little better, and the lighting gives the bottles and flowers nicer contrast, even though only one light was used.

To create more playful shadows in the fourth image (right), I placed an umbrella light at left with a second one farther back at front right above the arrangement to brighten the shadows and background. The

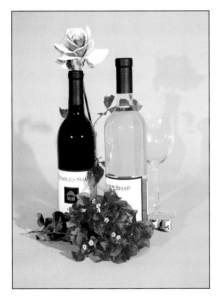

The first image was lit solely with a spotlight. The angled shadow shows that the background was curved.

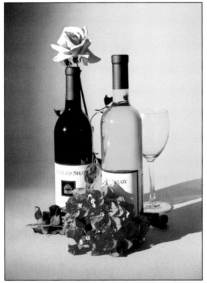

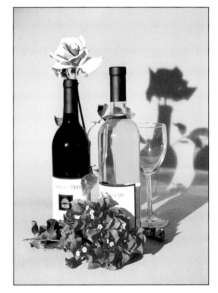

*Left—The main light is now a quartz unit reflected from an umbrella at right front, with another quartz light and umbrella at left front slightly farther away. You can see that the light at right was closer because it washed out the shadow from the light at left. **Center**—In the third image, an umbrella light was positioned up high and to the left in front of the still life subjects. In this photo, the glass shows up a little better, and the lighting gives the bottles and flowers nicer contrast, even though only one light was used. **Right**—I placed an umbrella light at left with a second one farther back at front right to brighten the shadows and background. The rose emerging from the bottle and its shadow was appealing, and the glass is finally visible.*

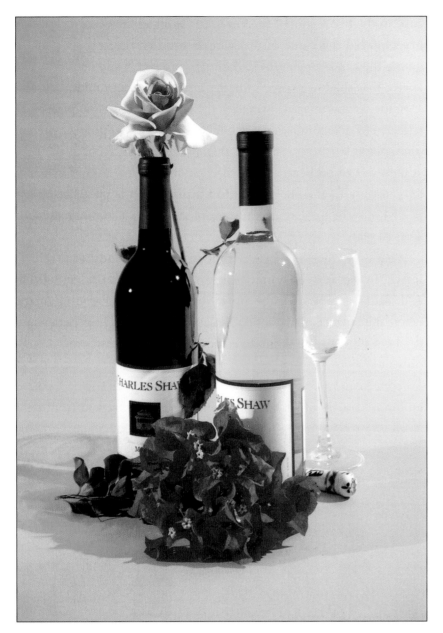

To create the final image, two umbrellas were used—one at 90 degrees right and the other farther back and left to fill in the frontal shadows. The result is a more subtle lighting pattern with more pleasing shadows.

rose emerging from the bottle and its shadow was appealing, and the glass is finally visible.

In the final image (above), one quartz-into-umbrella light at 90 degrees right was the main light on the bottles and the background. Another quartz-into-umbrella, positioned farther back at left filled the front shadows. You can see tiny round umbrella reflections on the dark wine bottle. The lighting is more subtle here with pale shadows, and ad copy placed in the space at right beside the bottles would work well.

Kitchen Still Life

Basic studio lighting techniques can be transferred to other venues, such as a kitchen for still life images or a living room for portraiture.

If home is where you hang your hat, a studio is where you bring your lights to take serious pictures. My wife, Kathy, had separated a head of lettuce, washed the leaves, and laid them on a towel to dry. The arrangement seemed an ideal still life. I slid the towel and lettuce onto a drawing board covered with a piece of white background paper and transferred the potential still life to a kitchen counter. A large red pepper, scallions, carrots, and asparagus were added to the greens, mainly for color. For this series I used one B800 AlienBees flash unit rated at 320WS. For the first image, this compact monoflash was aimed at a white ceiling that reflected light to the still life in a nice, even way.

In the second image (bottom right), the composition is the same, but I moved the light to the left so it hit the veggies at an angle to create more distinct shadows and added contrast. Had I been shooting in a studio, I could have used a high umbrella for a similar effect.

In my kitchen studio I could also have reflected quartz light from the ceiling, and the pictures would have resembled these ones closely. Exposures would have been much longer because of an 80A filter to correct the color temperature on color negative film, but with the Canon A2 on a Bogen 719B Digi Tripod, still life exposures can run into seconds if necessary.

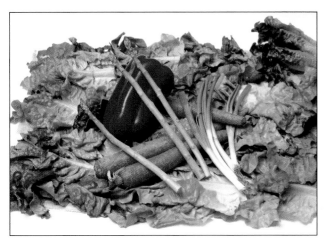

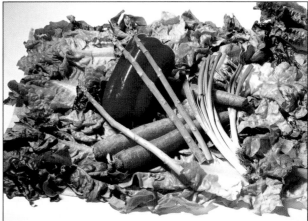

Top Left—White background paper, colorful subjects, and a B800 flash unit rated at 320WS were the ingredients needed in this still life recipe. Reflected light, bounced off of the ceiling, provided even illumination. *Top Right*—I moved the light to the right, thereby illuminating the vegetables from an angle. This change in position resulted in long shadows and added contrast. *Right*—Here's the setup used to create the first image in this series.

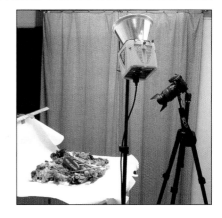

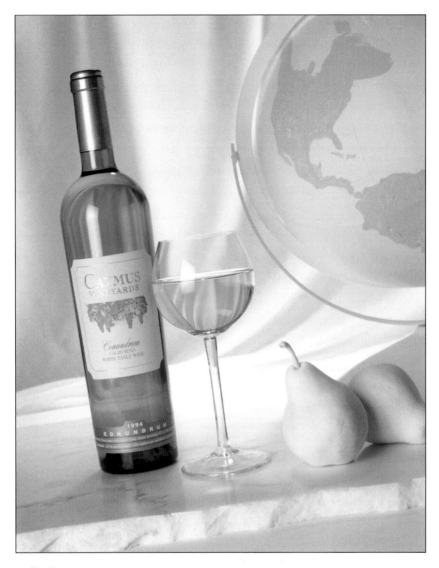

Still Life Treats

Roger Rosenfeld, whose studio is in San Rafael, CA, is an expert in photographing still lifes. His lovely sunflower image opened this chapter, and two of his commercial studio images (above and right) become our visual dessert.

Try to shoot similar high key pictures on your way to lighting expertise. The effort may not be easy, but you can create pale shadows in a bright background with canny visual judgment. When you get a lighting effect you like, enjoy your own variations of Roger's original.

Your Turn

Selecting Your Subject Matter. Choose whatever you will enjoy photographing, and make compositions to suit your fancy. Find objects around home or things you discover at thrift shops. Children's colorful blocks, flowers, leaves, or items related to a hobby are all possibil-

*Left—An illustration for Caymus Vineyards was also photographed with a 4 x 5-inch view camera and a 250mm lens. To attract attention to the bottle, the surroundings are high key, and the bright tones connote a sense of delicacy. Roger used a medium-size softbox as the main light from the right rear with a large softbox fill in front. The lighting was planned to be almost shadowless to support the overall mood. **Above**— Roger illustrated Asian Salmon for a magazine article on food, using a 4 x 5-inch view camera and a 250mm lens. That's equivalent to using a 135mm lens on a 35mm camera. A food stylist prepared the food, and Roger created the composition. To light it, his main flash came from a medium-sized softbox at right, and his fill light was a softbox, dimmed down, just to the left of the camera. The main light accented form and texture. A third light with a gold gel tinted the food gently from just right of the camera. The chopsticks in the background are intentionally out of focus. With 1000WS electronic flash units, Roger was able to stop down to f/22 on ISO 100 film.*

ities. Make a theme grouping if you wish, such as small antiques. As you compose a still life, vary the shapes, sizes, and colors for more interesting pictures and to increase your lighting challenge. Still lifes have been a favorite subject of painters and photographers for centuries, so leaf through art and photo books for ideas with impact.

For additional inspiration, clip still life pictures in magazines and newspapers, including advertising and editorial illustrations. Professional still life shooters have their own skillful ways to light shapes and materials that might baffle less experienced photographers, but try. Watches and perfume bottles are more difficult to light than luggage or other items that have few reflections. White and light-colored backgrounds are good for glass. A neat technique is to place objects on a raised sheet of glass (supported at each end), with a white or pastel background below. Lights need to be deftly placed to be reflected from under and behind the objects to avoid shadows and limit reflections.

Try using small reflectors, such as 11 x 14-inch pieces of white cardboard, to brighten reflective articles, or place white cloth diffusers over your flash. Diffusers for hot lights must be mounted at a safe distance. Please understand that you can go crazy trying to emulate the lighting in some still life pictures you see—especially if computer manipulations were used. Keep your sanity, and be resourceful. Put your faith in doing basic lighting exercises and get fancy later.

Note: If you shoot still lifes with flash, experiment with both umbrellas and softboxes. Both offer pleasantly diffused light, and creating comparison pictures of the same subject will be enlightening.

> As you arrange a still life, consider yourself a designer.

As you arrange a still life, consider yourself a designer. The composition may or may not have a theme—it's your call—but try to make it interesting, attractive, or both. For still life exercises such as those earlier in this chapter, try to keep the lighting uncomplicated, at least at first. Unless you prefer a dramatic presentation, shadows should be lit, even if just dimly. Be aware of surface textures that can be used in a decorative way. The lighting you select can accent them or subordinate them.

Choose lighting that will enhance color and form. Soft lighting is usually diffused by a softbox or umbrella. Would you prefer dramatic lighting? If so, think *pizzazz*, and use undiffused lights where and how you please. How much you diffuse them will affect the mood and impact of your pictures.

The Positive Power of Still Lifes. I hope it's clear that still life photography offers a graceful entry into the intricacies of studio lighting. It gives you confidence and experience with light control. As you take

pictures and make mistakes, you will also get really good pictures that show how well you managed your lights. This know-how can motivate you to create more images to make you proud, especially when others ask how you did the lighting. You will be glad you worked like crazy to master the subtle lighting effects that studio practice makes possible. Play with your lights and subjects. Play seriously, and the returns can be serious. The payoff comes when you shoot still life images and portraits for love *and* money.

This World War II British Army compass was photographed by Robert Rathe for a brochure cover. The beam of light was created by a focusing spot light and the shadows were made by glass blocks and smaller lights. Shot on 4 x 5-inch transparency film. The view camera's lens was tilted to limit the depth of field.

Basic Portrait Lighting

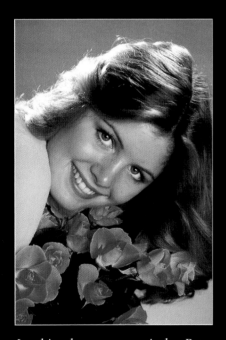

In this glamour portrait by Peter Gowland, the main light was a six-foot Larson softbox plus deft umbrella fill and hair light, which together revealed Chris Hall's beauty.

If you've read this book from the beginning, you'll find that some terms covered earlier are once again presented in this chapter. While this repetition will reinforce skills learned earlier in the book, it is presented for the benefit of those delving into the book to read first on portraiture.

Some Facts of Light

I've been looking forward to this chapter. Photographing people is an exciting challenge, and portrait lighting techniques are especially important to studio photography. Highlights and shadows in a portrait are not a mystery, but doing them right may be a puzzlement until you have experience. Portraits also involve posing, rapport with the subject, and distinctive timing.

Here are some basic reasons why we shoot portraits:

• To make people look attractive and please them. To capture them in a smooth, soft, and subtle light you need skill at professional lighting.
• To shoot publicity pictures where lighting can be similar to that used for personal portraits, but shadows may be darker to make

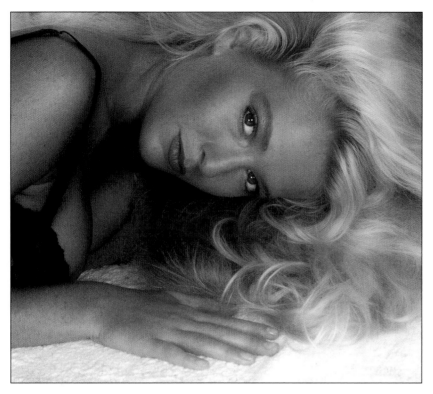

"I use a horizontal format often to give pictures a different look," says Peter Gowland, who photographed model Morgan Miller using two thirty-inch flat umbrellas. Glamour photography is a combination of smooth lighting, a beautiful model, and a skilled photographer.

people look more impressive. Studio portraiture for newspapers and magazines fits in this category.

- To glamorize celebrities and models with dramatic lighting and perhaps strong shadows.
- To make interpretive, artistic portraits that may be moody and reveal personality.

Motivations. Your lighting may be lovely, but a good rapport helps people form positive feelings about themselves and about your ability. Lively conversation with your subjects is a big plus. Almost everyone likes attention, so ask about the sitter's expectations. Trust the positive power of distraction.

My aim is to teach lighting techniques that you can adapt for yourself to please people. The challenge of lighting itself should motivate you to practice. I hope you find favorite lighting styles, for fun or profit, from this chapter's many lighting illustrations. Learn to design portrait lighting and you'll be able to devise numerous variations to suit your needs.

Light and Shadows. Do you know good portrait lighting when you see it? Are you aware of lighting styles? If you're not quite sure, how do you approach highlights (the stronger or brighter light) and shadows (the darker tones)? Lighting contrasts are important tools to master. (The five pictures on page 90 show contrast typical of the mid-twentieth

The challenge of lighting itself should motivate you to practice.

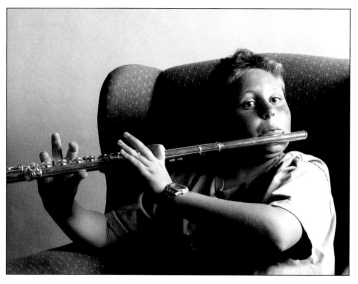

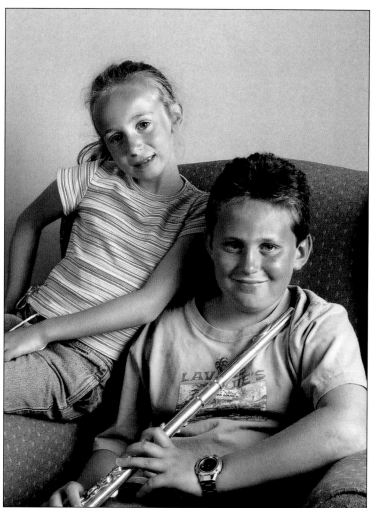

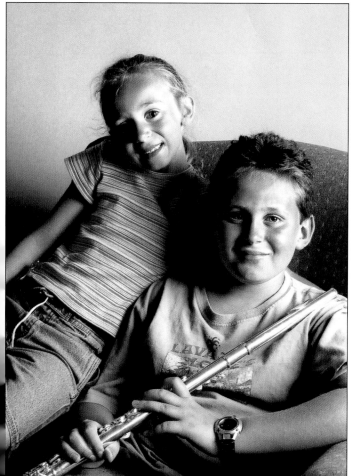

Top Left—*A large softbox on the right was the main lighting for the boy playing his flute.* **Top Right**—*The same softbox was the main light for the boy and his sister, and an umbrella light was added at the left.* **Bottom Left**—*The softbox alone provided a somewhat different mood.* **Bottom Right**—*Using just the umbrella flash produced playful lighting that seems to match the children's mood. These four images were chosen from a group of thirty-six exposures as a mini-story.*

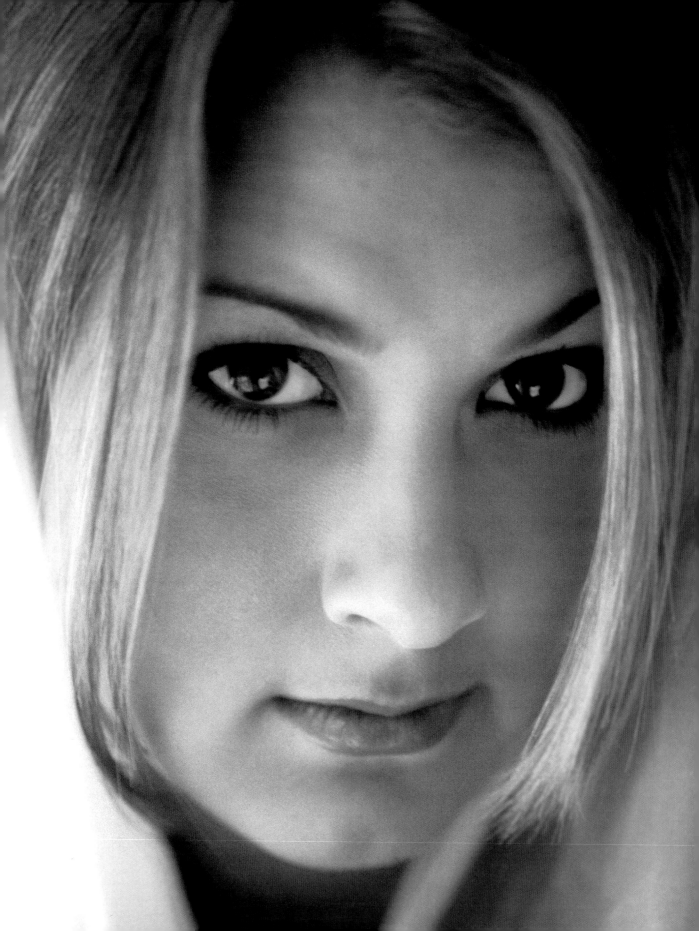

century.) Glamorous lighting is great to know, but careful imbalance also creates drama.

For Inspiration. With experience and from studying your pictures you learn instinctively where to place lights to make subjects look good, or to emphasize character or mood. For added incentive, collect portraits you admire from magazines and newspapers. Try to emulate the lighting in the best images as a personal challenge. Search libraries and book stores for examples of portrait photography, and become familiar with painters known for portraiture, such as Vermeer and Rembrandt. Find treasuries of inspiration in museums and galleries.

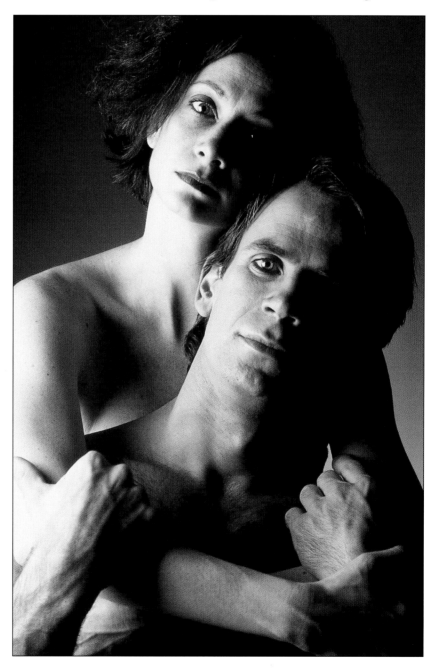

Facing Page—By this time, if you have analyzed portrait lighting as reflected in the eyes of models, you will recognize that this soft portrait was made with two softboxes, one at left and the other at right. It's another skillful job that Brian King does so well. The picture was a digital capture. **Right**—*Lou Jones arranged to photograph dancers at the Boston Ballet because he knew they would look more relaxed as models in this pose. A bank of several strobes in a softbox provided dramatic light.*

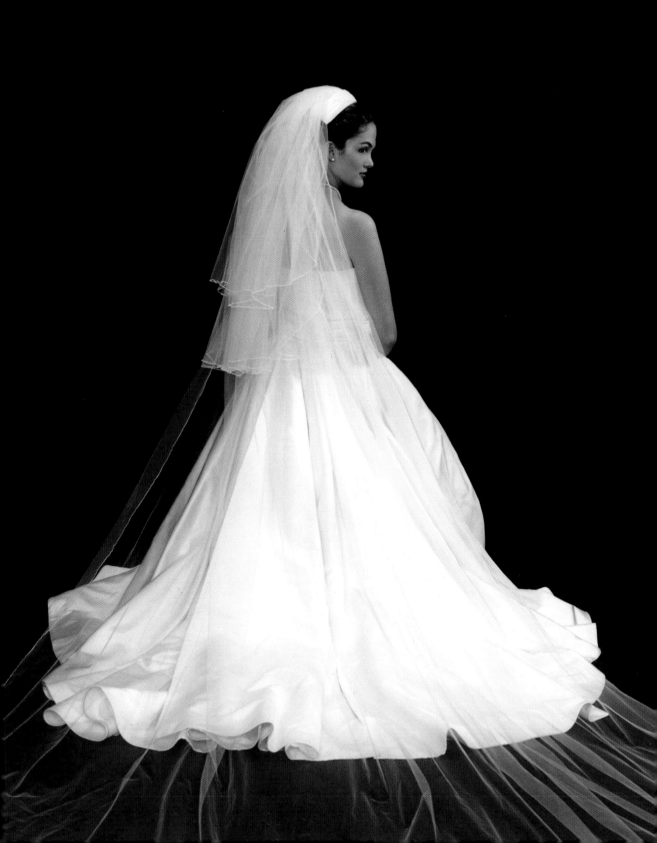

Metering Techniques

Hot Lights. Make exposure readings through your camera lens, or use a separate meter. Direct the meter at the subject in the studio as you would outdoors or at the lights (incident mode) and compare readings. Most meters average reflected light readings by combining highlight and shadow values. Incident readings measure light falling on the subject. With color negative film, the indicated exposure is usually good, but bracket exposures with more exacting slide film. A flash meter can also be used to determine hot light exposures. Remember to use exposure compensation when it seems indicated.

Flash Guide Numbers (GN). These are established by flash manufacturers via uniform tests and are listed in instruction booklets. Divide a guide number by the distance from flash to subject to determine an exposure. For example, GN 80 divided by 10 feet equals f/8. GNs are mainly used with nonautomated portable flash and are impractical and laborious with studio flash.

Studio Flash. A flash meter is recommended for studio use. Incident metering studio flash has worked very well for me. Hold or place the meter at the subject with the white sphere toward the lights, test-fire the flash, and the meter indicates an f-stop. As you dim, brighten, or move your lights, additional meter readings should be done.

Remote Flash Firing. Almost all studio units have a built-in slave unit that fires the strobe when it senses light from another flash. I activate my studio units with an old Sunpak 1600A flash mounted on the camera with its head aimed toward the ceiling or a wall. Its flash seems minimal, but it invariably causes the AlienBees and White Lightning flash units I use to pop beautifully in unison.

Lighting Terms and Practical Tips

Some of these will refresh your memory, and some are new. They are not listed in order of importance.

- Front light, side light, back light, top light, and 45-degree light are self-explanatory terms that describe studio lighting.
- The main or key light is brighter, and the fill light illuminates shadows. A light may be brighter because it's closer to the subject, or because it is more powerful. For example, a 320WS flash is twice as bright as a 160WS flash from the same distance.
- Contrast comes in two modes. Lighting contrast compares brightly lighted and shadow areas. Subject contrast refers to the tonality of people, places, and things, such as light or dark clothing or back-

Above—Roger Rosenfeld used a flash meter to get the proper exposure for this smoothly lit fashion picture. It's what I call one-sided light, and it makes the model and his jacket stand out. *Facing Page*—For a startling effect Roy Madearis posed a bride in white against a black background with gray tones reserved for the bottom of the frame and the woman's pretty face. A large softbox above the figure was the only lighting. The background absorbed the light.

grounds. Overcome excessive contrast by adding light to dark areas or subjects. To increase contrast for pictorial effect, darken shadows.

- A lighting ratio, such as 2:1, indicates that the highlight area is twice as bright as the shadow area. To determine a ratio, make a reading for the key light alone and another for just the fill light. For example, f/11 for the highlight illumination and f/8 for the shadows would be a 2:1 ratio. You may also eyeball the difference between highlight and shadow, and adjust the lights accordingly. If a shadow seems too dark, move the light closer or boost flash power; when a highlight seems too bright compared to a shadow, move the light farther away or dim it.

- Nose shadows are like sundials indicating light direction. To avoid a nose shadow, aim a light at 45 degrees from each side of the face.

- Many electronic flash units and some hot lights can be dimmed or brightened, and internal flash modeling lights can be set to follow the same adjustment. It took me a while with modeling lights to evaluate what I was seeing because they create less contrast than flash. (The contrast difference between shadows and highlights is easier to recognize with hot lights.) Study the nuances of lighting in your prints and decide what kind of shadows you want to avoid or brighten. You can learn to estimate contrast without having to continually measure lighting ratios.

Portraits

Series One. The following portraits illustrate forms of studio lighting. In some pictures the lighting is flawed, which is explained, and addi-

Left—Too much shadow area is frustrating when a pretty face is partly obscured. If it happens accidentally and you like it, call it mysterious. A softbox at right lighted the model and the background. **Center***—Here's the same pretty face again. The softbox was moved slightly forward from the previous image, and on the shadow side is an umbrella light, dimmer than the main light, to brighten the shadows. The ratio is about 2:1 and looks pleasant. The background color was diluted by bright light.* **Right***—The lighting here looks similar to that in the previous picture, but only one softbox was used at right. The background was not lit to create appealing contrast with her long, golden hair. Jamie's look is glamorous in a somewhat different way than in the previous picture.*

tional pictures show improved lighting. Shown are common lighting techniques and pictorial effects I expect you to create by trial and error. Each caption includes information on the lights that were used.

A Softbox Note. The size of a softbox or umbrella isn't always crucial to smooth lighting. Involved as well is the distance from the softbox or other diffuser to the subject. The light from a 24 x 24-inch rectangular softbox three feet from a face should be as soft as using a forty-eight-inch octagonal softbox six feet from a portrait subject. Shoot pic-

Left—Stephanie's all-American look came from her expression and pose. She was lit by a softbox at right (her nose shadow indicates where the light was positioned). At left was another softbox brightening her face and the background, too. The red sweater and green background were chosen for a Christmas picture. *Right*—A 45-degree light, also a side light here, may come from one side or the other. In this case it's on the left, slightly higher than Lisa's face. It is the main or key light from an umbrella and there's another, weaker umbrella light on the shadow side of her face. The hair light (also known as a back light) was a high quartz unit, and I exposed at $^1/_{30}$ second for it, knowing the main illumination was the flash popping at $^1/_{1000}$ second. Light spilled onto the background.

During a portrait session with Monika in chapter 4, I shot this comparison pair. One umbrella flash on the left created a dark side in the first picture that was filled in the second one by a white reflector near the camera. The nose shadow is almost the same in each image.

tures with a softbox and/or umbrella at several distances from a subject to better understand how distance and subject size influence light sources.

Series Two. On page 81 and 82 you'll find some lighting arrangements similar to those used before, but such variations on lighting themes are common and expected. A person's face and pose often suggest where you place lights, and serendipity plays a role. Move lights when you see an effect you can improve. *Stop, adjust, and evaluate.* The more portraits you take, the better your lighting and posing instincts become.

Left—What's wrong with this lighting? It wouldn't be passable even if Stephanie didn't look so forlorn. The dark side of her face emphasizes that mood, but the shadows are not attractive. The lighting can be improved fairly easily. *Center*—This is a prettier pose shot with a diffusion filter over the 80mm lens as an experiment. A softbox at each side of the camera created even lighting, and another flash from the back highlighted Stephanie's hair. The background received light from the softboxes. Shadowless lighting is popular in portrait photography. *Right*—The softbox to the right of the camera has been raised, and at the left another softbox was pushed backward to brighten her cheek and hair. Her shoulder turned toward the camera is a welcome posing variation. The diffusion filter over the lens is more apparent here.

Left—This is the best lighting so far, and the diffusion filter is gone. The softbox at right has been lowered, and the one at left fills the shadow side, creates a hair light, and brightens the new background. I set the light at camera right for sheen on her hair. *Center*—Stephanie's expression is the best yet, and the background is the same. The softbox at the right is slightly farther back (note the shadow on her blouse), but the softbox at the left hasn't changed. I included similar pictures to emphasize that lighting changes may be minimal. *Right*—Chin-on-hand works well if the hand is not too prominent. The softboxes at left and right put highlights on her hair and shoulder. I think this was one of the posing and lighting combinations that Stephanie liked best.

*Left—Lights are arranged for a picture in my temporary studio. In the background is a reflector flood I tried for a hair light in the first picture on page 81; at left is a flash and umbrella; another flash is aimed into the umbrella pointed at Stephanie. **Right**—One flash into an umbrella lighted this charming over-the-shoulder pose. You can tell from the nose shadow that the light was beside and above the camera. I eliminated the background light because I liked the contrast with Stephanie.*

Lighting Two People

The way you position a couple has a strong influence on how you light them. A main light from one side works if you avoid the shadow of one person on the other. A main light from near the front, or back far enough to be even on both subjects, is a good solution. Consider using a separate hair light for each of the people, if a single light doesn't work for both. Hope for patient models who allow you time to adjust lights frequently. Take plenty of pictures. Some results will be a lot better than you anticipated.

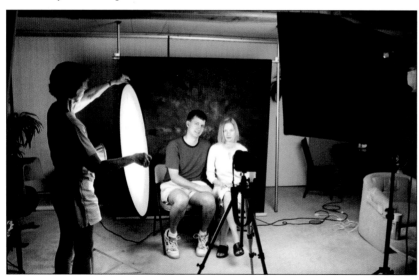

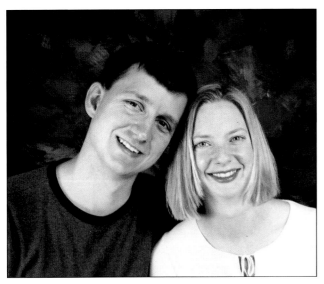 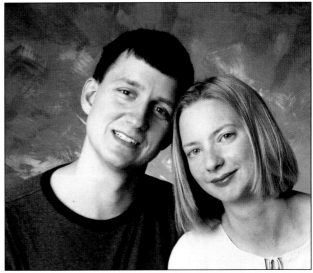

Facing Page (Bottom)—*Furniture was moved aside in the living room for space to position poles that are tensioned between the ceiling and floor to hold the Denny background. The main softbox is at the right (pulled back to see the models) and Kathy is holding the diffuser in front of a barely visible flash. I shot this with Kathy's Canon Rebel 2000 and a 28–80mm Canon lens.* **Left**—*This image of Monika and her husband Theron was taken in my living room studio. The main light was a rectangular softbox placed just to the left of the camera, with an umbrella light slightly farther right of the camera. Both were 160WS flash units, offering a pleasant way to light a couple evenly. No background light was used to increase the contrast.* **Right**—*The softbox was moved to camera left, Monika was posed to eliminate face shadows, and there was a 150W flood bulb on the background, a handsome one borrowed from the Denny Manufacturing Company. My wife, Kathy, held a cloth diffuser in front of a dimmed-down flash at the left, as seen in the bottom photo on page 82.*

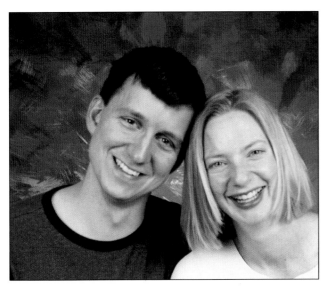

Left—*The softbox is now centered and raised. Portraits are a pleasure when you're prepared to capture dual electronic flash smiles. For this and many of the pictures in this series, my 28–135mm zoom was set between 80mm and 100mm.* **Right**—*The lighting hasn't changed from the previous shot, but I separated their heads to see the striking background between them. I once thought eliminating shadows on the background was difficult, but it's not.*

Above—Portrait professional Brian King posed these teens near a window located at left. He placed a round silver reflector under their chins "to add more punch to their eyes and faces," he told me. The lighting and intense expressions dominate this portrait that Brian shot with a digital camera. *Right*— Roy Madearis is fond of shooting black & white images at weddings, which offer a candid sense reminiscent of a photojournalistic style. Roy used two umbrellas to catch this vibrant scene of the bride surrounded by her cheering section. He shot the image on a medium-format camera.

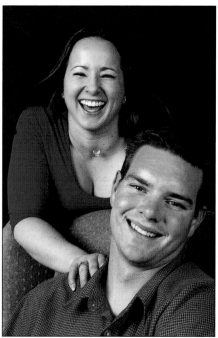

Left—I posed Jamie and Allison together in an upholstered chair I brought to my borrowed studio. The main light was an octagonal softbox at the left with a 320WS flash inside. The light also brightened the background. At the right, I dimmed-down a 160WS flash reflected from an umbrella for weak fill on their shadow side. **Right**—Jamie and Allison stand out from a black background that's worth trying among your portrait experiments. The octagonal softbox is at left but closer to the camera than in the previous shot, and there's a white reflector at the right for faint fill. Some portrait success is due to the rapport you create with your subjects. I said something to make the couple relax and look so handsome.

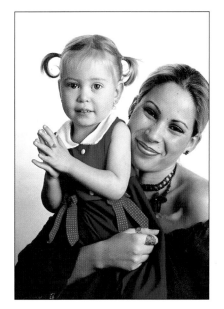

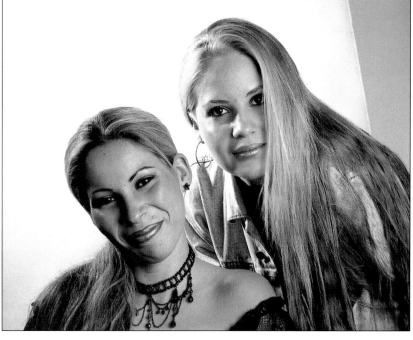

Left—In this mom-and-daughter shot, the child was not interested in posing. Her mom and I cajoled her, and I used a small toy duck to get this expression. The main light was a rectangular softbox near the camera at right, and fill light bounced back from flash on the background. **Right**—These sisters were photographed with a softbox at right and an umbrella at left, which was aimed at the background and the sister, farther back. The lighting style would suit a magazine illustration as well as the conventional portrait I created.

During lighting practice your imagination will suggest poses that will call for different lighting strategies. A few variations follow.

Top Left—*Jamie is a photographer friend and a very good model. I hung a large bolt of dark-blue fabric on my rolling background stand (see page 50) and placed a rectangular softbox at his left. A white reflector at right brightened the shadow side of his face. Portrait lighting for men can be a little more casual than for women.* *Bottom Left*—*The rest of the Jamie series relates hands and face. This one was taken with one softbox beside the camera.* *Right*—*A single softbox at left created a smooth lighting effect.*

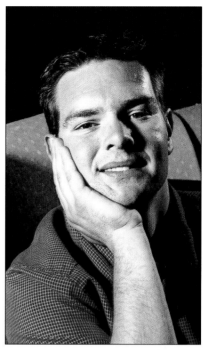

Right—Again, one softbox, placed farther to the right, created a shadow side to Jamie's face. The resultant lighting style seems to fit his expression. **Far Right**—Next, I placed the softbox at the left and partially lit his face at right using an umbrella as a 45-degree backlight. The shadow on his face is interesting without being objectionable.

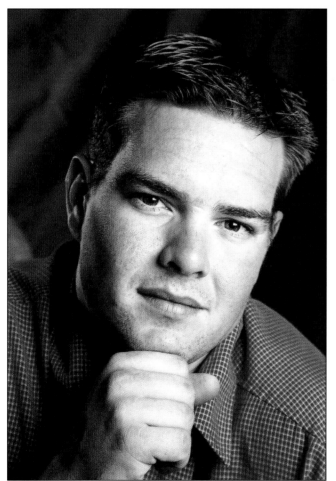

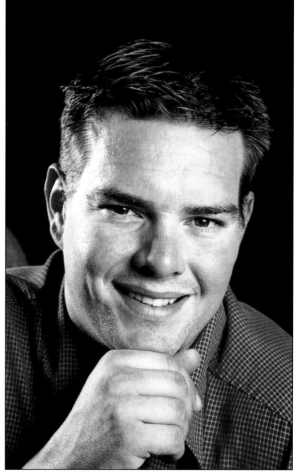

Left—This image was taken with one softbox placed at the right of the camera, which is a strong way to light men. At left was a dimmed-down umbrella flash that separated his face and hair from the background. I like this thoughtful portrait. **Right**—The main light in front is almost the same as in the previous picture, but the umbrella flash at left was repositioned for a brighter effect.

It's an understatement that not every portrait you take is suitable for framing. In this book I've shown a few lighting experiments that don't succeed, as evidence that professionals also make technical errors.

Left—Lisa is an actress in New York and a beautiful woman. The main light was a softbox at left with another at right dimmed down for fill. She looks lovely.

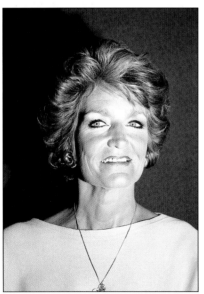 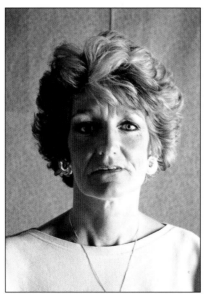

Left—Some lighting experiments that don't work show how beauty can be photographically disguised. This is awful beneath-the-face lighting, which is rarely flattering. One undiffused flash was used. Center—This is one-sided light. Sometimes it can help dramatize a portrait, but here it's questionable and unpleasant. Right—One umbrella light above the subject's head at right is also unpleasant lighting, especially without fill light to soften shadows. It's interesting that her hair looks beautiful. The background was lit separately.

 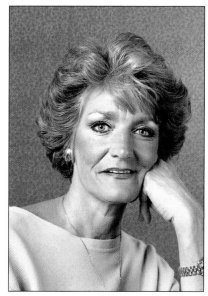 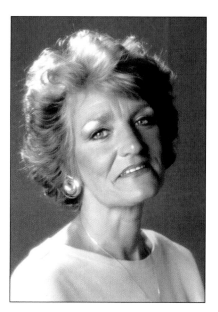

Left—Here, an umbrella was added at the left to soften the shadows that resulted in the previous setup. Looking straight into the camera, Lisa looks uncomfortable. This is a what-not-to-do example. ***Center***—Here the beautiful Lisa is lit properly with a softbox at left and another at right and farther away, to brighten the shadow side. ***Right***— This glamorous lighting variation was saved for last. There was a softbox at left, a white reflector at right, and a hair light for sparkle. As indicated, not all my lighting experiments succeeded. All pictures were taken on 35mm color negative film.

Postscript

Please look this chapter over several times. Some advice is repeated because similar lighting is used on different models. I hope you take portraits with the enthusiasm I felt. When you do, others will be happy with your images. Here's some summary guidance:

- When you begin shooting, think, "How will light look best on this person's face?" Then experiment. Move lights, shoot, and move them again to achieve pictures that excite you.
- Change poses fairly often. Each time, the lighting may have to change to boost a subject's visual appeal.
- For variety, consider raising the camera slightly to make people more photogenic.
- How many lights you have is less important than how cleverly you use those at hand.

Phil Dunham was a police detective who long enjoyed photography as an avocation. He had a studio in his garage in California when we met, and these portraits show his strong lighting style. He focused his talents on medium-format portraits and also shot striking landscapes. Sadly, Phil passed away in mid-2003, and this selection of his striking portraits (plus one on page 93) is a small memorial.

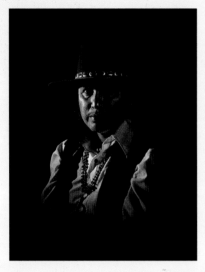 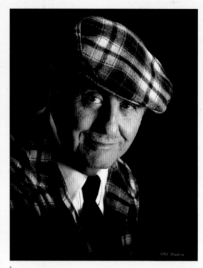

*Left—Phil preferred robust portrait lighting, especially for men. This model was photographed with silver umbrella flash at left and a soft white reflecting fabric at right. Phil excelled at an emerging-from-the-background approach. **Center**—The main light at 45 degrees from the left was balanced by a second umbrella flash, dimmed down at right, and a hair light was placed high behind the model at left. Phil diffused the portrait slightly when he made an enlargement. **Right**—This was lit with a 3:1 ratio. The key light at right, from an umbrella, was about three times as bright as the fill light at left from another umbrella. This is a character study as well as a portrait.*

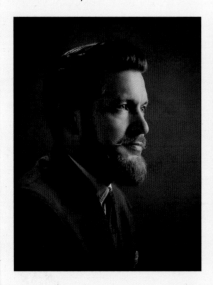 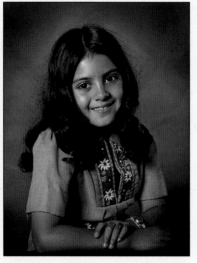

*Left—To create a background, Phil hung a piece of brown carpet on the wall and set an umbrella flash above and to the right of the subject's head at a 45-degree angle. A white styrofoam reflector at left gently brightened the shadow side. **Right**—The key light was an umbrella flash at left front. Note the small nose shadow. A background light created a pale halo around the model.*

Photographing Groups

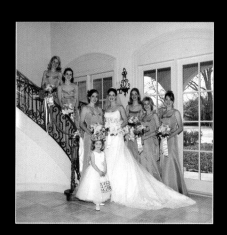

A bride and her party of bridesmaids gracefully posed on a staircase. All the subjects were equidistant from the large umbrellas that Roy Madearis positioned on each side of his digital camera.

Groups Are Not that Different

Most of us have taken many group pictures, such as people at parties with flash or groups of new graduates outdoors in shade. In each case we try to arrange people so their faces all show. Lighting is certainly a goal, but it's also important that you have everyone's attention. I use several techniques, like saying "you all look grim," to make people smile. If I'm at ease, the group is more relaxed, and that works with kids too.

This tactic applies to photographing groups in the studio, where you often have more time to make proper arrangements. Basic techniques for lighting groups are similar to those discussed for individuals or couples. Groups are not that different. Here are brief guidelines:

Posing Options
- For small groups, pose everyone standing.
- Pose the front row standing and second row raised on a bench or step.
- Organize the group with the front row sitting or kneeling, and the back row standing.
- Compose the scene with everyone seated, with the camera elevated to better see those in the back.

- Pose the group informally on a carpeted floor.
- Pose a group on a staircase with space between them for people behind to be seen. I once did this with fifty people on a huge hotel staircase, as described later in this chapter.

Group Lighting Variety

- For two, three, four, or five people, a softbox that's three-feet wide should cover everyone evenly. Place the light on one side of the camera far enough back to cover the group, and raise it if you want to avoid the flat light that's characteristic to flash on the camera.
- For smooth, shadowless lighting, try two softboxes or umbrellas, or one of each, set at the same power at approximately 45 degrees to camera left and right. Undiffused flash also works, though it creates shadows with sharper edges.
- A background light or two placed behind groups is often worthwhile. It may be tricky to evenly light each person, but experiment until it works.
- Flash is quick, and so are unexpected facial expressions. You can't watch everyone in larger groups, so shoot enough pictures to beat the likelihood of momentarily distorted faces. Get quality out of quantity.

Professional Lou Jones had limited time to photograph this singing group before their performance. He placed one softbox a few feet higher than their heads at the right for a vivid light–dark pattern. With 35mm slide film, he shot at various apertures to vary the depth of field. He preferred those in back in softer focus.

Phil Dunham, whose portraits end chapter 8, photographed a family in their living room with studio flash. At left was a flash unit and umbrella as the main light, and another flash was bounced off the ceiling for fill. Dunham metered the floor lamp area and set his shutter speed so the lamp light would look normal. The portrait was made on a medium-format camera and color negative film.

Brian King gracefully posed the family with two seated and two standing, so there's an implied arc across their heads. He told me, "I use windows in the studio to light a part of the set. The main light is provided by a softbox at camera left and fill comes from bouncing daylight." Note that they all dressed alike.

 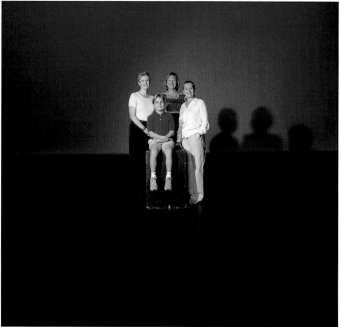

Left—*Allison McBee was a staff photographer for* Desert Magazine, *published by the* Palm Springs Desert Sun. *This image was a two-page opening to a story about artists, teachers, and students in a group devoted to arts education. Allison spaced them out on a stage and lit them with two flash units, one at each side. The people at the left and right are more brightly lit than those in the center, which makes for visual variety. Allison used a medium-format camera and transparency film. Courtesy of* Desert Magazine. *Right*—*Here, Allison McBee grouped this foursome around a youngster sitting on a trunk. One flash unit was the main light placed just left of the camera, as you can tell by the small nose shadows. Pale shadows in the background were almost totally cropped out in the magazine. The camera was a medium format loaded with transparency film. Courtesy of* Desert Magazine.

INVERSE SQUARE LAW

The sun is a vast light source that stays uniformly bright near and far. Man-made lights are subject to falloff, due to the inverse square law, which states that man-made light intensity decreases as a subject moves farther from the source. At double the distance, only a quarter of the light reaches the subject.

Falloff from hot lights and flash in a studio is not a problem when subjects are only six or eight feet from an average-size light. The phenomenon becomes more noticeable when subjects are ten or twenty feet away. I once used a four-foot octagonal softbox beside the camera on a ten-foot stand to photograph fifty people on an ascending staircase. Those in front and halfway up the stairs were fairly evenly lighted. Falloff is noticeable about fifteen feet from the camera, and the last few rows, about twenty-five feet away, are a stop or more darker.

When photographing groups, raising the main light better illuminates those in the back. If possible, place a light on each side of a large group to better deal with falloff.

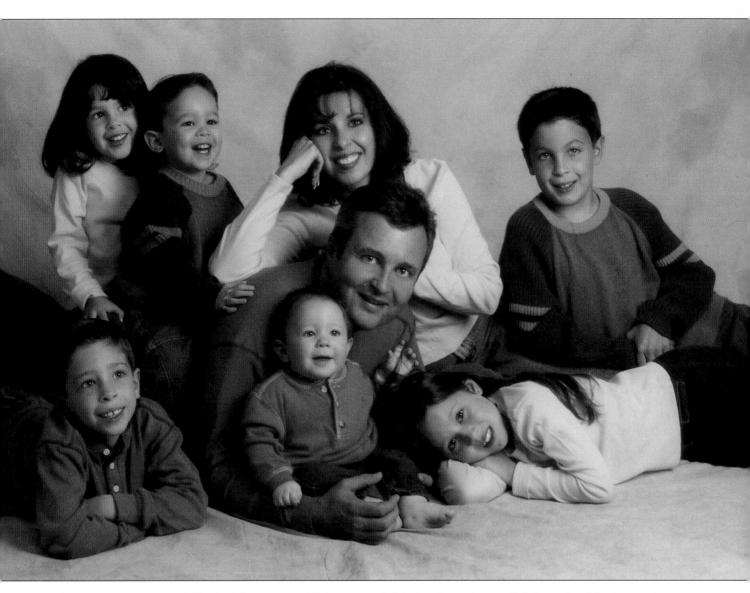

Frank Frost, a portrait specialist in Albuquerque, NM, arranged this family against a slightly textured background. The main light was a large softbox at right with careful fill from another flash reflected from the ceiling. He directed the parents, and his assistant distracted the children with bubbles and puppets. Frank used a Mamiya 645 AFD, which has both film and digital backs. This was a digital shot.

ELITE
team

Brian King says, "A girl brought some of her swim team friends to the studio to do a fun picture for their coach. She asked the guys to take their shirts off, and show their muscularity. I had them stand under lights mounted in the ceiling. This image was made while they waited for me to check the exposure. In Photoshop I darkened the shot to create a more chiseled, sculpted look. Below them is the name of their swim team."

Image Gallery

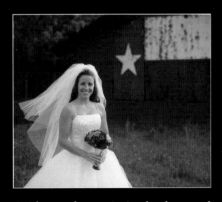

Bride and patriotic background make a memorable image. Roy Madearis posed her momentarily during an after wedding session.

Previous chapters have given you a lot of how-to information and a variety of useful and attractive photographs. My own pictures are gratefully augmented by outstanding images lent to me by generous photographers. I have been fortunate to know men and women who have lighted many beautiful images with great technical skill.

Ending this book is a selection of those images. Visually appealing, graphic, and otherwise intriguing pictures demonstrate studio lighting creativity. Captions describe how the pictures were made and offer occasional insights into how photographers think. While you study techniques, please reflect too about pictorial concepts. How did a photographer get that visual idea? How can you generate fresh lighting and posing ideas too? As you learn, you will be adapting new ideas and new ways to expand your lighting abilities.

In the pages that follow are pictures to inspire you to fresh photographic challenges. Whatever equipment you enjoy using, put it to work. Make a list of your ideas to stimulate experiments. Motivation breeds resourcefulness. Take risks and earn fun and satisfaction.

In closing, I encourage you to try offbeat lighting techniques such as special light-diffusing setups. I wish you luck with all your studio photography.

Above—For this striking image titled Barrier, Derald Martin constructed a black frame to which he cemented pieces of broken bottles, which he carefully fractured for this project. More glass was cemented to black paper on a table behind which the model sat. Her nose shadow indicates the flash was at top right, and a bit of light was reflected by glass to the shadow side of her face. The image was shot on a medium-format Mamiya RB67 camera using transparency film. *Facing Page*—Instead of just posing this teen portrait, Brian King staged it in the studio using a large window. The slanting white lines frame the darker figure in an abundance of space.

Left—Clark Coleman is a movie stunt man and, says Peter Gowland, "When we met I got the idea for this portrait made on 4 x 5-inch Fujichrome. The key light was at front right, hair lights were on both sides in back, and a third light was at the right side." He used a 4 x 5-inch Gowlandflex camera, which he invented and manufactures. *Right*— Peter Gowland made another shot of Clark Coleman to include the four lights. In front was the key light at right. Peter told me, "We had fun dreaming it up. We had to bring a motorcycle up steps and into the studio." This image was also created using the 4 x 5-inch Gowlandflex camera and transparency film.

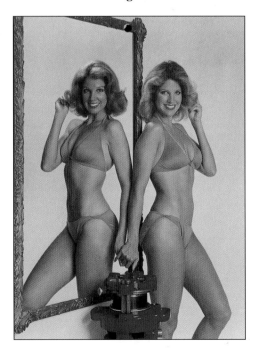

Left—Peter Gowland photographed Twins with Mirror for a calendar series. The actual mirror was removed from its frame, which was set against a white background in the studio. The twins were posed holding hands to confirm there were two models. Four flash units lighted the white background, and the main light at camera right was a seventy-two-inch Reflectasol umbrella. Is this an illusion you would like to emulate, with head shots or full figures? *Facing Page*—Five images, all lighted in a consistent manner with a large softbox, were montaged by Brian King in Photoshop. The eyes in the large portrait catch your attention first, followed by the guitar and then the small photos. The lighting and contrast between the black clothing and pale skin draw attention.

jason

Facing Page—How do you light a subject looking at the camera at an angle? Brian King did it with a softbox at left using an eye-catching pose he does so well. This was taken with a Kodak DCS 760 digital and a Tamron 28–105 lens set at about 100mm. **Right**—In this image, studio lighting goes outdoors for a change of pace. Brian King found a rustic and romantic setting for a couple who must have been entranced by the sound of the falls. This was shot on Kodak film in a Mamiya 645 Pro camera. The soft shade lighting helped make the mood.

Left—While Brian King was polishing his family photography, he learned how to tackle informal studio situations from Scott Cubberly and his sister Monica Cubberly-Early, owners of the studio where Brian is now a creative artist. This young man's enjoyment helps make the picture.

Right—To illustrate bubbles in a glass, I placed a slice of orange in the bottom and anchored the cherry stems out of sight at top so they would not float up when I poured 7-Up in. I used a 50mm close-up lens on a 35mm SLR and placed hot lights closely to allow a $^1/_{180}$-second shutter speed. I emptied the glass and an assistant poured again for a few more shots. At the time I didn't own studio flash, which would have made freezing the bubbles easier.

Facing Page—Robert Rathe created an eye-catching still life close-up using a 4 x 5-inch medium-format camera to soften focus on the target front and back. In Photoshop, he produced the glow at the ends of the darts. The lighting was diffused flash. *Above*—Norm Kerr carefully lit these colorful plastic dishes, a cup, and a brush with one diffused flash high above the still life. The light was masked to keep it off the background, but it did brighten the top edge of the cup. This still life was for a company promotion. Courtesy of the Eastman Kodak Company.

Top*—Jill Walz asked a friend to model for an experiment. In front at left was a spotlight covered with a red gel, and behind the smoke was another spotlight with a blue gel. Jill made half a dozen exposures to be certain of a good smoke pattern using a 35mm SLR and Kodak color negative film. Notice the lovely rim light on the model's face. Courtesy of the Eastman Kodak Company. **Above Left****—Add fun to your studio photography by asking friends to jump for the camera. If a portrait sitting needs a boost, a jump session can loosen up your model (and you, too). Stephanie enjoyed jumping, and I shot at the height of the jump. Most studio flash units operate at $^1/_{1000}$ second and faster, making them ideal for action. Both Stephanie and the background were lit by a softbox on each side, and I handheld an SLR with color negative film. **Above Right****—As a personal project Peter Gowland set four flash units on the background, two left and two right, and aimed a 600WS flash unit into a seventy-two-inch Larson silver umbrella at camera right. The couple leapfrogged until Peter knew he had the action he wanted. Try your own version of jumping or any other fast activity you can dream up to test your timing.*

Who is this handsome guy? Before asking Brian King, who created the portrait, I was certain it was Johnny Depp. Brian shot it in 2002 and says he was not aware of the resemblance at the time. Too bad, but the photograph is striking anyway. The picture was taken with prominent softbox light from the right.

Top—This pet portrait, created by Debrah H. Muska, shows the definition that is achieved when placing dark subjects against a black background. Notice the amount of detail that can be seen in the pups' eye area. The absence of color and light in the background lets the viewer observe the puppies' expressions more clearly. *Center*—Debrah H. Muska also photographed this Turkish Angora, which insisted on laying with its back to the camera. A strong flowing "C" composition was developed from the tip of the tail, up the spine, and to the nose. To obtain this purr-vocative look, the teaser enticed the cat to look over its shoulder at the lens. *Bottom*—Marge McGowan got up close and personal with her cat using a close-up lens on a 35mm SLR and a single flash that put highlights in the cat's eyes. She shot Kodak ISO 100 negative film and handheld the camera to be ready when the cat moved. Courtesy of the Eastman Kodak Co. *Facing Page*—This model cat belongs to Victoria Mal. Lighting was a thirty-inch soft silver umbrella at left and a dimmed fill light at right. Just before the exposure, Victoria's hand movement caught the cat's attention. Nicholas is a fifteen-year-old Chinchilla Silver Persian, one of a series of pets photographed for a department store promotion. A 4 x 5-inch view camera loaded with Kodak Portra NC was used to capture this shot.

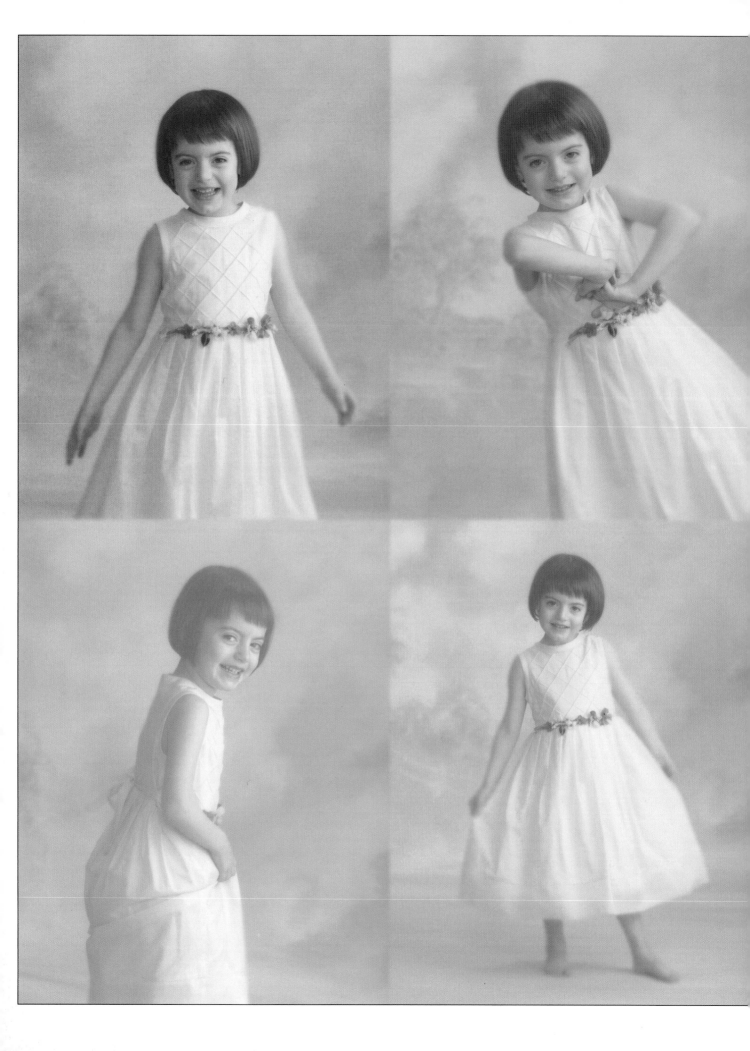

Facing Page—Brian King enjoyed photographing this young lady using two softboxes to create an almost shadowless series. "The child was a pleasure to work with," Brian says, "and her parents enjoyed this foursome of impressions." **Top Right**—A mom-and-child portrait was created in the style of a fine painting by Roy Madearis. He set a softbox at camera right and another at left with the flash dimmed. Separate smaller flash units created highlights and shadows on the elegant background. Roy's assistant caught the baby's attention while Roy talked to the mother. **Bottom Left**—This was part of wedding coverage in the studio where Brian King was intrigued with a straight-down view of this young lady. It's atmospheric and bright, and in the wedding album another portrait of the subject was placed next to this. Think of it as a symbolic, soft pose. **Bottom Right**—Colorful, delightful setups for youngsters attract clients at many studios where children enjoy being photographed. The little lady felt at ease on Roy Madearis's set, where the key light was a broad softbox near the camera, another on the background, and a reflector at left. Roy shot with a Hasselblad and Kodak Portra 400 film.

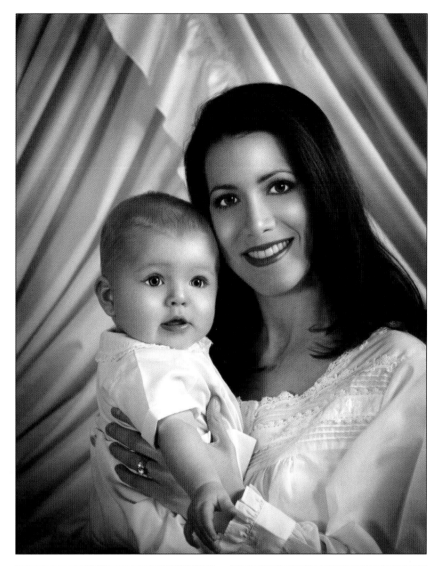

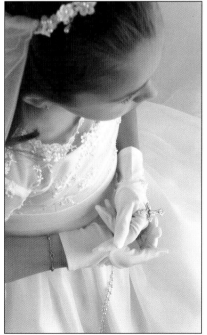

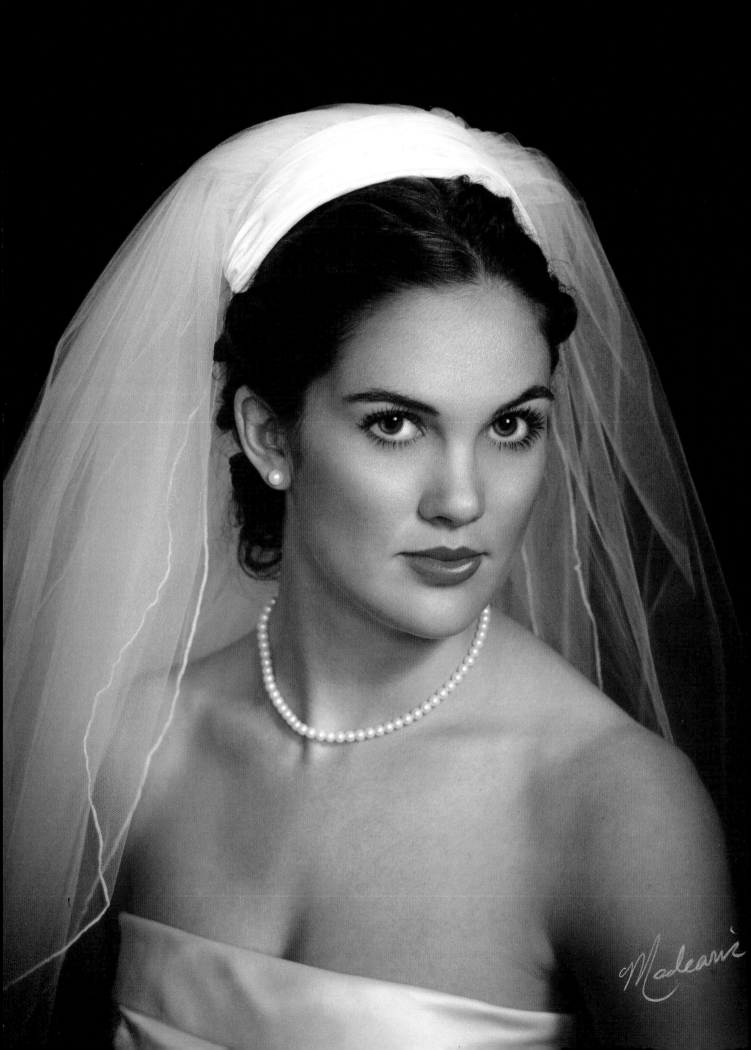

Facing Page—Roy Madearis, a popular studio photographer in Arlington, TX, chose a dark background as contrast for a lovely bride. A large softbox was positioned higher than the camera and to its right, and a reflector softened the shadow side. Portraits are often taken with digital cameras, though Roy used a Hasselblad film camera and Norman strobes. **Above**—To frame the bride and groom dancing slowly, Roy Madearis asked seven couples to dance more vigorously around them. He set his Hasselblad on a tripod on a balcony and shot a series of ambient-light pictures at $^1/_8$ second and $^1/_4$ second using Kodak VC film.

Above—When a muscular dad brought his cherubic child to Frank Frost's Albuquerque studio, Frank created this enchanting father-and-baby masterpiece he titled Built-In Security. He used a Larson Starfish, a curving softbox that wraps the light partially around the subject. He shot with a Mamiya 645 camera fitted with a Stage One Lightphase digital back. Images were downloaded into a computer for immediate inspection. *Left*—Robert Rathe photographed his friend Perry as a personal project. At right of the camera he placed a softlight (his term for a softbox), and a reflector next to the camera filled in the shadows. This was a medium-format film capture using a long focal length lens and an extension tube to minimize depth of field.

Right—This marvelous portrait was taken by Roger Rosenfeld for his portfolio. He posed a lovely model slightly tilted, with a diffused umbrella flash placed at right. He described it as a circular plastic diffuser with a hole in it to disperse the flash, attached with Velcro into the umbrella. At left, a reflector directed pale light into the shadow side. One

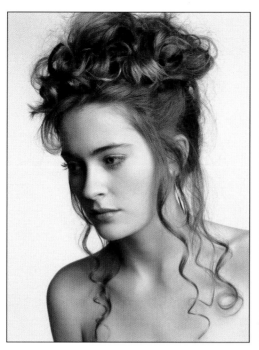

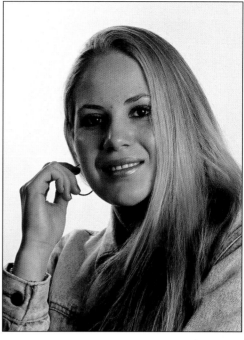

flash on each side brightened the background. **Far Right**—This model will seem familiar, but the lighting variation is different and delightfully flattering to the model. The main light was a softbox. Ordinarily a darkened eye would be objectionable, but it's part of the shadow pattern that helps to shape her face. The background light put highlights on her face and jacket. **Below**—In a friend's studio a few years ago I was monitoring his use of flash, and he invited me to take pictures of his model. I placed a softbox at front left and a large umbrella on the background. A reflector at the right brightened shadows.

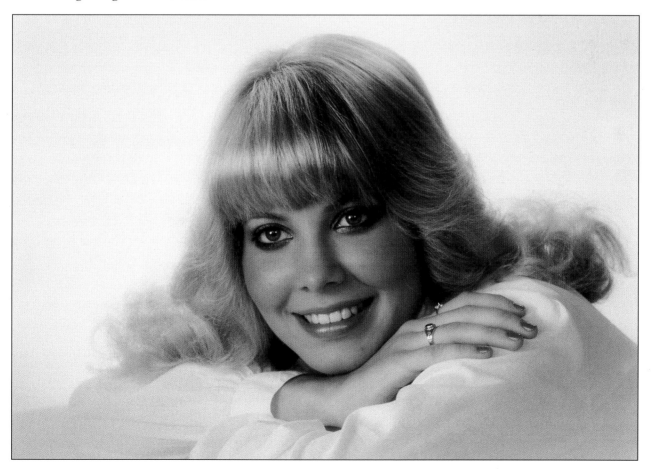

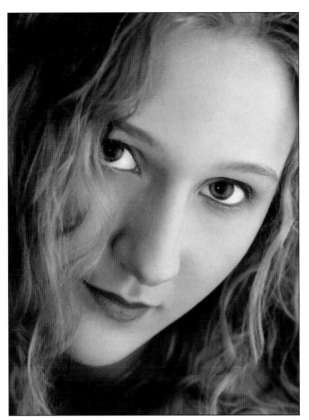

Left—Brian King's portrait of a high-school senior is up close and bold, a technique that he enjoys with the younger set in particular. He used a softbox at right with a faint reflector fill at left. Getting in close, tilting the camera or the model's head, and using strong, simple lighting offers pictorial rewards. Taken with a Mamiya 645 Pro with a 120mm macro lens on Kodak Portra ISO 400 film. Image saturation was improved in Photoshop. **Below**—How does one create soft and beautiful lighting like this? Frank Frost used a Larson Starfish—a curved softbox that was placed near the camera—as key light, and fill came from a 5 x 2-foot softbox suspended three feet below his studio's twelve-foot ceiling. The main light has more power and concentration than the high fill, which spreads light softly like invisible snowflakes. The camera was a Mamiya 645AF with a digital back. Try a lighting and posing arrangement like this in your own shooting space.

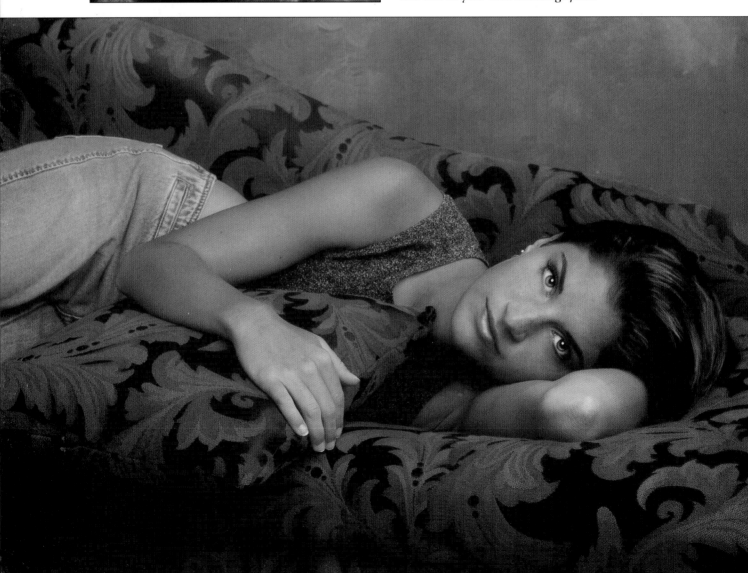

Above—*Derald Martin titled this double exposure* Silent Scream, *to symbolize the woman who can't be heard. He lighted the model with an umbrella flash at the left, using a black background. For the second exposure, created against a red background, the model turned profile and silently screamed. Derald shot with only the background light on. He made prints from a medium-format transparency.* **Top Right**—*Greg is an imaginative portrait by Brian King. The primary image was photographed with a softbox at camera right and a reflector at camera left to illuminate the guitar. Brian created the negative "shadow" in Photoshop, saying, "I think a strong understanding of design principles goes a long way when generating new images with Photoshop."* **Bottom Right**—*Phil Dunham hired a handsome model who wore a cleric's robe and cross for this well-planned double exposure. The background profile was shot first against a white background, and for the second image he used a brown background. Phil lit both images with a single flash, and shot with a Hasselblad and black & white film. You can be very precise making an in-camera multiple exposure, but they are not fully predictable. The print was made on Ektalure paper and sepia toned.*

Resources

The following companies are good resources for those seeking to purchase or get more information on studio electronic flash and quartz lighting units (hot lights), flash meters, softboxes, umbrellas, and other lighting accessories.

Before you shop, read equipment ads and articles in photographic magazines. View web sites like those listed below, request catalogs and literature, and make comparisons.

Companies

Adorama
A large store with a variety of brands and models including floodlight outfits
42 West 18th St.
New York, NY 10011
800-223-2500 or www.adorama.com

AlienBees, Inc.
A division of Paul C. Buff, Inc.
Economical studio flash units in colorful cases
530 East Iris Dr.
Melrose, TN 37204
877-714-3381 or www.alienbees.com

Backdrop Outlet
Backdrops, props, posing equipment
2215 S. Michigan Ave.
Chicago, IL 60616
800-466-1755 or www.backdropoutlet.com

B&H Photo
A large store with a variety of lighting equipment, background paper
420 Ninth Ave.
New York, NY 10001
800-221-5743 or www.bhphotovideo.com

BKA—Brandess-Kalt-Aetna Group, Inc.
Excalibur SP Studio Flash Systems, Lancerlight Flash series, some economical sizes, softboxes, high-wattage quartz hot lights, and lighting kits
701 Corporate Woods Pkwy.
Vernon Hills, IL 60061
847-821-0450 or www.bkaphoto.com

Bogen Photo Corp.
Elinchrom and Metz flash equipment, flash meters
565 East Crescent Ave.
PO Box 506
Ramsey, NJ 07446-0506
201-818-9500 or www.bogenphoto.com

Bowens International
Bowens moonlights, studio accessories, Bowens 750 PRO Flash

R.T.S., Inc.
40-11 Burt Dr.
Deer Park, NY 11729
631-242-6801 or www.bowensinternational.com

Britek
Store specializing in studio lighting and kits
12704 Marquardt Ave.
Santa Fe Springs, CA 90670
800-283-8346 or www.briteklight.com

Calumet Photographic
Studio flash units, kits, umbrellas, accessories, comprehensive catalog
Retail locations: Los Angeles, San Francisco, Chicago, Boston, NYC
800-225-8638 or www.calumentphoto.com

Chicago Canvas & Supply
Backdrops in various materials
3719 W. Lawrence Av.
Chicago, IL 60625
773-476-5700 or www.chicagocanvas.com

Chimera
Light modifiers, diffusers
1812 Valtec Ln.
Boulder, CO 80301
888-444-1812 or www.chimeralighting.com

Denny Manufacturing Company, Inc.
Backgrounds and props, free catalog
PO Box 7200
Mobile, AL 36670
800-844-5616 or www.dennymfg.com

Dyna-Lite, Inc.
Studio flash equipment
1050 Commerce Ave.
Union, NJ 07083
908-687-8800 or www.dynalite.com

Peter Gowland
Gowlandflex 4 x 5-inch and 5 x 7-inch cameras, unique designs
609 Hightree Rd.
Santa Monica, CA 90402
310-454-7867 or petergowland@petergowland.com

JTL Corporation
Studio flash, hot lights, and accessories
14747 Artesia Blvd., 3E
La Mirada, CA 90638
714-670-6626 or www.jtlcorp.com

Konica Minolta Photo Imaging USA, Inc.
Camera Division
Flash meters
101 Williams Dr.
Ramsey, NJ 07446
201-825-4000 or www.minolta.com

Lowell-Light Manufacturing, Inc.
Quartz and floodlighting equipment (hot lights) and accessories
140 58th St.
Brooklyn, NY 11220
800-334-3426 or www.lowel.com

Mamiya America Corp.
Profoto studio flash units, PocketWizard digital wireless slave units, Sekonic flash meters
8 Westchester Plaza
Elmsford, NY 10523
914-347-3300 or www.profoto-usa.com

Photo Control Corp. (Norman Division)
Studio flash and accessories
4800 Quebec Avenue N.
Minneapolis, MN 55428
800-787-8078 or www.photo-control.com

Paterson Photographic Ltd.
Studio flash units
4680-A Industrial Access Rd.
Douglasville, GA 30134
770-947-9796 or www.patersonphotographic.com

Photoflex Products, Inc.
Softboxes, dome reflectors, and lighting accessories
97 Hangar Way
Watsonville, CA 95076
800-486-2674 or www.photoflex.com

Photogenic Professional Lighting
Studio flash units
525 McClurg Road
Youngstown, OH 44512
800-682-7668 or www.photogenicpro.com

Photographer's Outlet
Flash units, stands, accessories
4800 Quebec Av.
Minneapolis, MN 55428
800-375-3560 or www.photographersoutlet.com

Photographer's Warehouse
Studio flash units and accessories
525 McClurg Rd.
Youngstown, OH 44512
800-521-4311 or www.photographerswarehouse.com

SinarBron Imaging
Broncolor studio flash
17 Progress St.
Edison, NJ 08820

800-456-0203 or www.sinarbron.com

Smith-Victor Corporation
Quartz, photofloods (hot lights), and studio flash, kits, and accessories
301 N. Colfax St.
Griffith, IN 46319-2849
800-348-9862 or www.SmithVictor.com

Speedotron
Studio electronic flash
310 S. Racine Ave.
Chicago, IL 60607
312-421-4050 or www.Speedotron.com

The FJ Westcott Company
Reflectors, backgrounds, and accessories
1447 N. Summit St.
PO Box 1596
Toledo, OH 43603
419-243-7311 or www.fjwestcott.com

White Lightning
A division of Paul C. Buff, Inc.
Studio flash units and accessories
2725 Bransford Ave.
Nashville, TN 37204
800-443-5542 or www.white-lightning.com

Recommended Reading

Basic Studio Lighting, Tony L. Corbell, Amphoto Books, 2002.

Beginner's Guide to Photographic Lighting: Techniques for Success in the Studio or On Location, Don Marr, Amherst Media, Inc., 2004.

The Business of Studio Photography, Edward R. Lilly, Allworth Press, 2002.

Corrective Lighting and Posing: Techniques for Portrait Photographers, Jeff Smith, Amherst Media, Inc., 2000.

Creative Lighting Techniques for Studio Photographers, 2nd Ed., Dave Montizambert, Amherst Media, Inc., 2000.

Lighting Techniques for High Key Portrait Photography, Norman Phillips, Amherst Media, Inc., 2003.

Lighting Techniques for Low Key Portrait Photography, Norman Phillips, Amherst Media, Inc., 2004.

Master Lighting Guide for Portrait Photographers, Christopher Grey, Amherst Media, Inc., 2004.

The Photographer's Guide to the Studio, Roger Hicks & Frances Schultz, David L. Charles Pub., Distributed by F+W Publications, 2002.

The Photographer's Lighting Handbook, Lou Jacobs Jr., Amherst Media, Inc., 2002.

Posing and Lighting Techniques for Studio Portrait Photography, J. J. Allen, Amherst Media, Inc., 2000.

Studio and Commercial Photography, Jack Reznicki, Kodak ProWorkshop Series, 1999.

Glossary

These terms come up in discussions with other photographers, in equipment literature, and in advertising. You'll also find many of them used in this book. Many are commonly used, and some are esoteric. The terms apply to lighting practice, to measuring light, and to lighting sources.

Accent light—A light, from one side or another, or from above, which is used to add a bright accent to hair and other subjects.

Aperture—Another term for lens opening or f-stop.

Back light—A light aimed from a position behind the subject that may create an accent light; its shadows are usually filled by front or side lights, especially for portraits.

Background light—A light placed behind the subject and aimed at the background to lighten it. A properly dimmed flash can be used as a back light. Alternately, you can use a quartz or floodlight. When combining these weaker hot sources with strobe, you'll need to use a slower shutter speed. Leaving the shutter open longer allows the hot light to continue to expose the film or digital sensor after the flash has fired.

Bare bulb—Using an electronic flash unit without its reflector.

Beam candlepower seconds (BCPS)—This rating defines the amount of light projected by a flash unit. It better describes light from a portable unit that generally projects a narrower beam than do most studio flash units. Portables (on or in-camera) suffer more light loss when used with diffusion than do studio units, so BCPS is not generally used to rate the latter.

Candlepower, footcandles, footcandle seconds, and beam candlepower are also light-rating terms you really don't need to shoot terrific studio pictures. Some are defined in a dictionary.

Bounce—To aim a light source (such as flash) at a reflective surface, such as a ceiling or wall.

Bracket—To make a series of exposures that differ from the metered exposure (half a stop or one stop more, and half a stop or one stop less, for example) to ensure a suitable exposure.

Color balance—A proper match of Kelvin temperature between the film and the light source so color is neither too warm nor too cool.

Color temperature—Measured in degrees Kelvin (K), these numbers are designated for specific places in the spectrum of light from a source. Sunlight measures about 5500K, and daylight film is balanced for this color temperature. Electronic flash units are made to produce light that matches daylight films. Hot lights (floods and quartz) are designed to offer 3200K and 3400K light, which is warmer than sunlight.

Contrast—The amount of separation between light and dark tones. Think of a zebra's pattern as being high contrast, and a tablecloth with white and pale yellow stripes as low contrast.

Depth of field—The areas in front of and behind the focused distance that are acceptably sharp in a photograph. Depth of field is determined by focus distance and lens aperture. Depth of field is increased by closing ("stopping down") the lens aperture, such as from f/8 to f/11.

Exposure compensation—To vary exposure for excessively bright (give extra exposure) or dark subjects (give less exposure) that a meter interprets as 18 percent gray. Most SLR cameras on the market include adjustments for exposure compensation.

Fill light—Indicates "filling" or brightening shadow areas in a scene with one or more lights.

Flash fill—Use of flash to brighten shadow areas in a photograph. Reflectors may be used for the same purpose.

Flash guide numbers—A recommended number into which one divides distance to the subject in feet to determine an f-stop. These are used mainly with nonautomatic portable flash and are not recommended with studio flash.

Flash meter—A meter that measures the brightness of the flash and indicates the f-stop for correct exposure at the selected ISO. The meter may also measure ambient light.

Flat light—Even lighting with little or no contrast. Flat light from a softbox may be beautiful, while flat light from an on-camera flash may be uninteresting.

Gray card—A gray-colored card that reflects 18 percent of the light falling on it. Used to set exposures or evaluate exposure meter readings.

Grid spot—A grid placed over a flash unit to concentrate and diffuse the light.

Guide numbers (GN)—These tell you what aperture to set for a given flash unit according to subject distance and film speed. For instance, a unit GN of 80 divided by 10 feet indicates a recommended aperture of f/8. Guide numbers are primarily needed for manual-exposure portable flash units, because studio unit flash exposures are almost always metered.

Hair light—When placed behind a portrait subject, at left or right, this light accents the side and/or top of hair. It is often used to separate a subject from the background.

Hard lighting—Refers to flash, floodlights, or quartz lights aimed at a subject directly or reflected from an umbrella, softbox, or a separate reflector.

Hot light—One of the terms used to describe photoflood and quartz lights that become very hot in use. Also called constant light.

Incident light—The light that falls on a subject from any source, as opposed to reflected light, which is light reflected by the subject. An incident light meter is designed to measure light falling on it, rather than reflected light.

ISO—An international standard to rate film sensitivity, or speed. A higher ISO number indicates a faster film, and a lower number indicates slower film.

Kelvin temperature—Describes the color of light, from very warm to very blue, expressed in K-numbers such as 2900K for average incandescent bulbs or 5600K for sunny daylight.

Key light—Also called the main light, it refers to the light closest to or brightest on the subject.

Light modifiers—Any device used to change the quality or spread of the light source. Used to make portraits more flattering and products more appealing. These include softboxes, umbrellas, and reflectors.

Lighting ratio—This ratio describes the relationship between the highlight area and shadow area in a subject or scene. As an example, a ratio of 2:1 indicates that the bright area of a scene or set receives twice as much light as the shadow area.

Lumenseconds—A measure of the quantity of light produced by a light source. For instance, if a bare flash tube (without reflector) requires an f/8 exposure, the exposure for the same tube in a reflector might be f/22. The flash tube itself produces the same amount of light in each case, but the reflector causes more lumenseconds to fall on the subject, while light from a bare tube is scattered.

Main light—Another term for key light.

Modeling light—Within the reflector of a studio electronic flash unit is a lightbulb that allows the photographer to get an approximate idea of the highlights and shadows the flash will create. Since the modeling light is of a lower intensity than the flash, it offers only an approximation of the effect the photographer can expect to achieve.

Monolight—A self-contained flash unit with its own power supply and flash head, typified by the White Lightning and AlienBees units used in the author's studio. Power pack systems with separate power supply and flash head are also used in studios. The are generally heavier and some are more powerful than monolights.

One-sided light—I use this term to describe light that is directed onto a subject from a single side. Shadows may be only dimly illuminated. One-sided light is often dramatic.

Pixel—A unit of measurement to describe digital image detail. The higher the pixel number, in general, the sharper the enlarged images should be.

Point & shoot camera—Also known as a compact camera, this type usually has a nonremovable zoom lens.

Recycle—Describes the interval after a flash unit is fired until it builds up power to flash again. Recycle times are noted in seconds.

Seamless paper—Rolls of heavy background paper available in many colors and widths traditionally suspended from a rod for use in a photographic studio.

Single-lens reflex camera (SLR)—A sophisticated camera that features interchangeable lenses. Often used by professional photographers.

Slave—A flash unit that fires by detecting the flash from another unit, allowing multiple light setups to operate without connecting cords.

Slave eye—An electronic sensor found on a slave that, when plugged or built into an electronic flash unit, activates that flash when another one is fired.

Softbox—A reflecting unit, usually lined in white with a translucent cover, used to diffuse electronic flash lighting.

Spotlight—A tungsten light with a glass lens in front. The light can be focused to wide and narrow beams. Useful for product photography.

Still life—Any inanimate subjects such as tableware or other objects of your choice photographed for fun or profit.

Strobe—Another name for electronic flash, shortened from *stroboscopic*, the original name for ultrafast flash.

Studio flash—Refers to electronic flash units mounted on stands and primarily powered by AC. Some flash brands offer portable battery packs that allow for the use of studio flash while shooting on location.

Sync—Short for *synchronize*; this term indicates the firing of two or more flash units at the same moment.

Umbrella—An umbrella-shaped reflector used to soften hot light sources or flash.

Watt-second (WS)—A unit that measures relative flash power or brightness. Flash units should be compared to each other via uniform testing conditions, which is not the case commercially but can be done in a studio. Watt-seconds provide a reasonable means for comparing flash unit light output, though manufacturers may vary in how they measure watt-second ratings in advertising or articles about their flash units.

A quantity of electrical energy, such as that which creates electronic flash bursts, is measured in watt-seconds. Watt-seconds define the amount of electrical power expended by a flash unit with each flash. Paul C. Buff, Inc., manufacturer of the White Lightning and AlienBees flash equipment I used for this book, rates their flash units in "true watt-seconds"—which are not inflated—and also in lumenseconds.

According to Paul C. Buff "true" watt-seconds and "effective" watt-seconds need to be distinguished. The effective watt-seconds can be "rather arbitrary" and cannot be easily proven. For instance, Buff notes that a unit such as their Series 800 UltraZap produces 330 true watt-seconds and 800 effective watt-seconds.

Index

Portrait Photography
THE ART OF SEEING LIGHT
Don Blair with Peter Skinner

Learn to harness the best light both in studio and on location, and get the secrets behind the magical portraiture captured by this award-winning, seasoned pro. $29.95 list, 8½x11, 128p, 100 color photos, index, order no. 1783.

Plug-ins for Adobe® Photoshop®
A GUIDE FOR PHOTOGRAPHERS
Jack and Sue Drafahl

Supercharge your creativity and mastery over your photography with Photoshop and the tools outlined in this book. $29.95 list, 8½x11, 128p, 175 color photos, index, order no. 1781.

Beginner's Guide to Adobe® Photoshop® Elements®
Michelle Perkins

Take your photographs to the next level with easy lessons for using this powerful program to improve virtually every aspect of your images—from color balance, to creative effects, and much more. $29.95 list, 8½x11, 128p, 300 color images, index, order no. 1790.

Posing for Portrait Photography
A HEAD-TO-TOE GUIDE
Jeff Smith

Author Jeff Smith teaches sure-fire techniques for fine-tuning every aspect of the pose for the most flattering results. $29.95 list, 8½x11, 128p, 150 color photos, index, order no. 1786.

The Portrait Photographer's Guide to Posing
Bill Hurter

Get the posing tips and techniques that have propelled over fifty of the finest portrait photographers in the industry to the top. $29.95 list, 8½x11, 128p, 200 color photos, index, order no. 1779.

Professional Digital Imaging
FOR WEDDING AND PORTRAIT PHOTOGRAPHERS
Patrick Rice

Build your business and enhance your creativity with the newest technologies, time-honored techniques, and practical strategies for making the digital transition work for you. $29.95 list, 8½x11, 128p, 150 color photos, index, order no. 1777.

Color Correction and Enhancement with Adobe® Photoshop®
Michelle Perkins

Master precision color correction and artistic color enhancement techniques for scanned and digital photos. $29.95 list, 8½x11, 128p, 300 color images, index, order no. 1776.

Fantasy Portrait Photography
Kimarie Richardson

Learn how to create stunning portraits with fantasy themes—from fairies and angels, to 1940s glamour shots. Includes portrait ideas for infants through adults. $29.95 list, 8½x11, 128p, 90 color photos, index, order no. 1777.

PROFESSIONAL TECHNIQUES FOR
Pet and Animal Photography
Debrah H. Muska

Adapt your portrait skills to meet the challenges of pet photography, creating images for both owners and breeders. $29.95 list, 8½x11, 128p, 110 color photos, index, order no. 1759.

Outdoor and Location Portrait Photography 2nd Ed.
Jeff Smith

Learn to work with natural light, select locations, and make clients look their best. Packed with step-by-step discussions and illustrations to help you shoot like a pro! $29.95 list, 8½x11, 128p, 80 color photos, index, order no. 1632.

Professional Secrets of Natural Light Portrait Photography
Douglas Allen Box

Use natural light to create hassle-free portraiture. Beautifully illustrated with detailed instructions on equipment, lighting, and posing. $29.95 list, 8½x11, 128p, 80 color photos, order no. 1706.

Professional Secrets for Photographing Children 2nd Ed.
Douglas Allen Box

Covers every aspect of photographing children, from preparing them for the shoot, to selecting the right clothes to capture a child's personality, and shooting storybook themes. $29.95 list, 8½x11, 128p, 80 color photos, index, order no. 1635.

Build Your Own Home Darkroom

Lista Duren and Will McDonald

This classic book teaches you how to build a high quality, inexpensive darkroom in your basement, spare room, or almost anywhere. Includes valuable information on: darkroom design, woodworking, tools, and more! $17.95 list, 8½x11, 160p, 50 b&w photos, many illustrations, order no. 1092.

Into Your Darkroom Step-by-Step

Dennis P. Curtin

This is the ideal beginning darkroom guide. Easy to follow and fully illustrated each step of the way. Includes information on: the equipment you'll need, setup, making proof sheets and much more! $17.95 list, 8½x11, 90p, 100 b&w photos, order no. 1093.

Professional Techniques for Digital Wedding Photography, 2nd Ed.

Jeff Hawkins and Kathleen Hawkins

From selecting equipment, to marketing, to building a digital workflow, this book teaches how to make digital work for you. $29.95 list, 8½x11, 128p, 85 color images, order no. 1735.

Toning Techniques for Photographic Prints

Richard Newman

Whether you want to age an image, provide a shock of color, or lend archival stability to your black & white prints, the step-by-step instructions in this book will help you realize your creative vision. $29.95 list, 8½x11, 128p, 150 color and b&w photos, order no. 1742

Power Marketing for Wedding and Portrait Photographers

Mitche Graf

Pull out all of the stops to set your business apart and create clients for life with this comprehensive guide to achieving your professional goals. $29.95 list, 8½x11, 128p, 100 color images, index, order no. 1788.

PHOTOGRAPHER'S GUIDE TO
The Digital Portrait

START TO FINISH WITH ADOBE® PHOTOSHOP®

Al Audleman

Follow through step-by-step procedures to learn the process of digitally retouching a professional portrait. $29.95 list, 8½x11, 128p, 120 color images, index, order no. 1771.

The Digital Darkroom Guide with Adobe® Photoshop®

Maurice Hamilton

Bring the skills and control of the photographic darkroom to your desktop with this complete manual. $29.95 list, 8½x11, 128p, 140 color images, index, order no. 1775.

Professional Strategies and Techniques for Digital Photographers

Bob Coates

Learn how professionals—from portrait artists to wildlife photographers to commercial specialists—enhance their images with digital techniques. $29.95 list, 8½x11, 128p, 130 color photos, index, order no. 1772.

The Portrait Book

A GUIDE FOR PHOTOGRAPHERS

Steven H. Begleiter

A comprehensive textbook for those getting started in professional portrait photography. Covers every aspect from designing an image to executing the shoot. $29.95 list, 8½x11, 128p, 130 color images, index, order no. 1767.

The Master Guide for Wildlife Photographers

Bill Silliker, Jr.

Discover how photographers can employ the techniques used by hunters to call, track, and approach animal subjects. Includes safety tips for wildlife photo shoots. $29.95 list, 8½x11, 128p, 100 color photos, index, order no. 1768.

Heavenly Bodies

THE PHOTOGRAPHER'S GUIDE TO ASTROPHOTOGRAPHY

Bert P. Krages, Esq.

Learn to capture the beauty of the night sky with a 35mm camera and some intermediate-level astronomical tools. Tracking and telescope techniques are also covered in this unique and higly informative book. $29.95 list, 8½x11, 128p, 100 color photos, index, order no. 1769.

Digital Photography for Children's and Family Portraiture

Kathleen Hawkins

Discover how digital photography can boost your sales, enhance your creativity, and improve your studio's workflow. $29.95 list, 8½x11, 128p, 130 color images, index, order no. 1770.

Photographing Children with Special Needs

Karen Dórame

This book explains the symptoms of spina bifida, autism, cerebral palsy, and more, teaching photographers how to safely and effectively capture the unique personalities of these children. $29.95 list, 8½x11, 128p, 100 color photos, order no. 1749.

Professional Digital Portrait Photography

Jeff Smith

Because the learning curve is so steep, making the transition to digital can be frustrating. Author Jeff Smith shows readers how to shoot, edit, and retouch their images—while avoiding common pitfalls. $29.95 list, 8½x11, 128p, 100 color photos, order no. 1750.

The Best of Children's Portrait Photography

Bill Hurter

Rangefinder editor Bill Hurter draws upon the experience and work of top professional photographers, uncovering the creative and technical skills they use to create their magical portraits. $29.95 list, 8½x11, 128p, 150 color photos, order no. 1752.

Wedding Photography with Adobe® Photoshop®

Rick Ferro and Deborah Lynn Ferro

Get the skills you need to make your images look their best, add artistic effects, and boost your wedding photography sales with savvy marketing ideas. $29.95 list, 8½x11, 128p, 100 color images, index, order no. 1753.

Web Site Design for Professional Photographers

Paul Rose and Jean Holland-Rose

Learn to design, maintain, and update your own photography web site. Designed for photographers, this book shows you how to create a site that will attract clients and boost your sales. $29.95 list, 8½x11, 128p, 100 color images, index, order no. 1756.

Wedding Photojournalism

Andy Marcus

Learn to create dramatic unposed wedding portraits. Working through the wedding from start to finish, you'll learn where to be, what to look for, and how to capture it. $29.95 list, 8½x11, 128p, 60 b&w photos, order no. 1656.

Studio Portrait Photography of Children and Babies, 2nd Ed.

Marilyn Sholin

Work with the youngest portrait clients to create cherished images. Includes techniques for working with kids at every developmental stage, from infant to preschooler. $29.95 list, 8½x11, 128p, 90 color photos, order no. 1657.

Classic Portrait Photography

TECHNIQUES AND IMAGES

FROM A MASTER PHOTOGRAPHER

William S. McIntosh

Master photographer Bill McIntosh shares the lighting, posing, and exposure strategies he relies on time and again to create his timeless images. $29.95 list, 8½x11, 128p, 100 full-color photos, Order no. 1784.

Photo Retouching with Adobe® Photoshop® 2nd Ed.

Gwen Lute

Teaches every phase of the process, from scanning to final output. Learn to restore damaged photos, correct imperfections, create realistic composite images, and correct for dazzling color. $29.95 list, 8½x11, 120p, 100 color images, order no. 1660.